GLASGOW AIRPORT

THROUGH TIME

Rob Bowater

AMBERLEY

Front cover top: Bill Crookston Collection. *Front cover bottom*: Bill Crookston Collection. *Back cover top*: Author. *Back cover bottom*: Iain Mackenzie Collection.

First published 2015

Amberley Publishing
The Hill, Stroud
Gloucestershire, GL5 4EP

www.amberley-books.com

Copyright © Rob Bowater, 2015

The right of Rob Bowater to be identified as the
Author of this work has been asserted in accordance
with the Copyrights, Designs and Patents Act 1988.

ISBN 978 1 4456 2285 9 (print)
ISBN 978 1 4456 2299 6 (ebook)

British Library Cataloguing in Publication Data.
A catalogue record for this book is available from
the British Library.

Typeset in 9.5pt on 12pt Celeste.
Typesetting by Amberley Publishing.
Printed in the UK.

Introduction

Abbotsinch has two distinct histories. First, between 1932 and 1965, it was a military aerodrome, and was home base to a famous Battle of Britain squadron and a Royal Naval Air station; since 1966 it has been Glasgow International Airport. As the latter, it has grown from a single terminal building to a large multifaceted complex with all the facilities of a small town. The aircraft on the stands waiting to fly to exotic holiday destinations have also changed; gone are the piston engine DC-3s, Herons and Viscounts of the Golden Age of Travel – the airport now handles modern wide-bodied jets, including the largest passenger aircraft ever built, the Airbus A380. Most types of airliners, including, on one occasion, a trio of British Airways Concordes, have graced the apron over the years. Unique among international airports, the aerodrome is also used by a flying club and a university air squadron, and a large passenger jet awaiting the arrival or departure of a light aircraft is a common sight. The following is a brief fly-past through the first eighty years of Glasgow's airport.

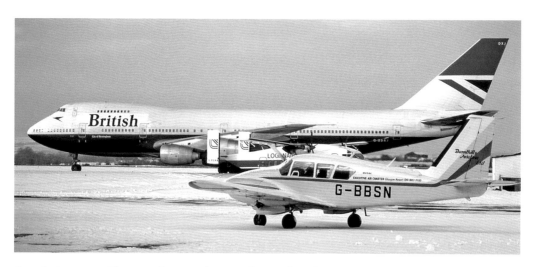

A typical scene at Glasgow airport, where civil aircraft and commercial airliners share the airfield. Burnthills Aviation Piper Aztec 250E G-BBSN, Loganair Short SD3-30-100 G-BGNA and British Airways 747-236B are seen in the snow of early 1982. (Paul Thallon Collection)

Acknowledgments

During the preparation of this book, I have been assisted by many very knowledgeable people: Brian McLean, Head of Communications & Public Affairs at Glasgow Airport (www.glasgowairport.com); Gerry Trainor of No. 602 Squadron Museum, Glasgow; members of the Glasgow Flying Club (www.glasgowflyingclub.com); and Graeme Kirkwood (www.graemekirkwood.co.uk/Airports/Glasair. htm). Although there is no longer a viewing gallery within the airport, there are several suitable vantage points around the perimeter of the aerodrome, and these have allowed for the photographs in the following pages to be taken. Special thanks go to Scott Bannister; Alistair Bridges; Dan Clark; Bill Crookston; Mohammad Farhadi; Nigel Garrigan; Dr Bartolomeo Gorgoglione; Udo Haafke (www. die-fotos.de); Brian Hill; Iain Mackenzie; Daniel Mattsson; John Macintyre; Jan Mogren; Ian Robertson; Neil Russell; R. A. Scholefield; Wallace Shackleton; Don Stirling; Paul Thallon; Michael West and Robert Woolnough. Many of the photographs can be found on airliners.net and jetphotos.com, both excellent websites for the civil aviation enthusiast.

Site

The 750 acres of land known as Abbots Inch are bounded to the south and west by the M8, to the east by the White Cart Water and to the north by the Black Cart Water.

In 1157, Walter Fitzallan, High Steward to King David I of Scotland, was given Renfrewshire and Ayrshire in recognition of his loyalty to the Crown, and in 1163 he founded a residence for monks of the Cluniac order from the priory of Much Wenlock in his native Shropshire. By 1219 this had become Paisley Abbey, and it is believed that the Inch was gifted to the monks sometime around 1200.

Although the land was rich and fertile, there were, and still are, areas of marshy, boggy ground; just such an area, in the south-west corner of the site, is today known as Paisley Moss. It contains twenty-two different types of grass and eleven types of sedge, while marsh orchids and the common blue butterfly can also be seen; it is also a home for wintering jack and common snipe. As it falls within the airfield boundary, the airport, in conjunction with Renfrewshire Council and the Scottish Ornithologists' Club, plays an active role in its management.

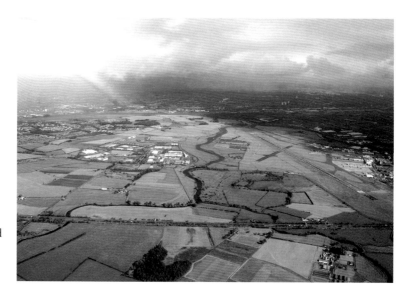

Rainbow over Glasgow airport. The photo shows the 750 acres of Abbots Inch, sandwiched between the Black and White Carts and the M8. (Nigel Garrigan Collection)

The Airport's Military Background

The aerodrome at Abbotsinch came into being in 1919 as an alternative landing ground for nearby Renfrew, but it was Lord Trenchard, Chief of the Air Staff, who ordered the construction of RAF Abbotsinch in 1932, due to the operational restrictions imposed on military flying at Renfrew by the growth of civilian traffic.

No. 602 (City of Glasgow), which had formed at Renfrew as a bomber squadron, moved to its new base on 20 January 1933, and in April that year the Commanding Officer, Lord Clydesdale, and one of his flight commanders, F/L MacIntyre, became the first men to fly over Mount Everest. Lord Clydesdale became Douglas Douglas-Hamilton, 14th Duke of Hamilton, while David MacIntyre formed Scottish Aviation.

The squadron's original DH.9 aircraft were replaced successively by Westland Wapitis, Fairey Fawns, Hawker Harts and, in June 1936, Hawker Hinds. Three of the latter joined a fly-past over nearby Ibrox football stadium when the king opened the Empire Exhibition in Glasgow on 2 May 1938, but with the storm clouds gathering

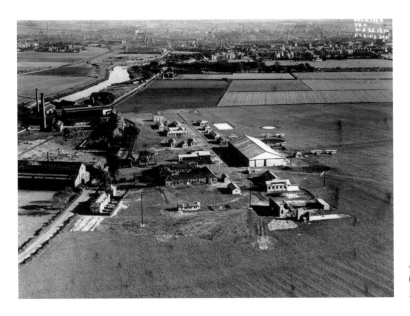

Abbotsinch in 1934.
(602 Squadron
Museum Collection)

over Europe, Hawker Hectors arrived on 1 November 1938, and the squadron temporarily became an Army Co-operation unit. On 14 January 1939, however, it joined Fighter Command, equipped with Gloster Gauntlets, and four months later, it became the first auxiliary squadron, and only the eighth in the RAF, to be equipped with the Supermarine Spitfire.

With the outbreak of war, the squadron moved to RAF Drem near Edinburgh, and on 22 October 1939, it shot down the first enemy aircraft to crash on British soil. Named the 'Humbie Heinkel' after the village where it crashed, one of its machine guns can be seen on display in Edinburgh Castle, and several other parts are in the No. 602 Squadron Museum in Glasgow.

The squadron was the longest-serving in the Battle of Britain, and between 1941 and 1943 it took part in sweeps and escort missions over France before it joined the Second Tactical Air Force, and from

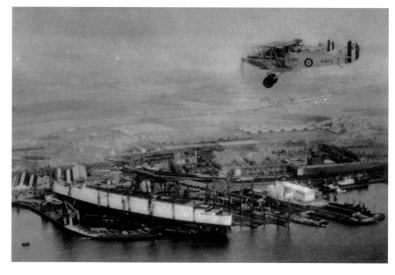

A brace of No. 602 Squadron Hawker Harts fly over RMS *Queen Mary* in the John Brown shipyard on the River Clyde in 1934. (602 Squadron Museum Collection)

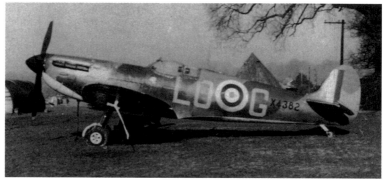

No. 602 Squadron Spitfire I X4382 LO-G destroyed three enemy aircraft in September 1940 during the Battle of Britain. (Author)

late June 1944 operated from airfields in Normandy in support of the Army. On 17 July 1944 one of its attacks severely injured Field Marshal Erwin Rommel, and the squadron finished the war flying attacks against V-2 rocket launch sites in Holland before disbanding on 15 May 1945.

Reformed at Abbotsinch on 10 May 1946 with Spitfire F.14s, it entered the jet age with Vampire FB.5s in January 1951, and when it finally retired its Spitfires in May 1951, it brought to an end the longest association of any RAF squadron with the iconic fighter. The final operational aircraft was the Vampire FB.9, which served until the squadron disbanded on 10 March 1957.

Reformed again on 1 July 2006, the squadron now trains Flight Operations and Intelligence support staff.

The Torpedo Training Unit formed at Abbotsinch in March 1940 to train RAF crews in the skills of aerial torpedo attacks, and was the main flying unit until 1943, when it moved its Beauforts and Hampdens to RAF Turnberry in Ayrshire, now the site of the world-famous golf course.

Just down the River Clyde, at Dumbarton, Blackburn Aircraft Ltd built the twin-engine Botha. The completed aircraft were then towed upstream on lighters and unloaded on a special slipway on the River Cart (near the end of the current runway) before being test flown from Abbotsinch. This slip is now used by the Airport Fire Service to launch their Zodiac rescue boats.

In 1941 the Merchant Ship Fighter Unit arrived with its Sea Hurricanes, nicknamed Hurricats. They were catapulted from the bow of a merchant ship to intercept the enemy, but had to ditch in the sea after their one and only flight. Only ever a stop-gap measure designed to protect convoys when out of the range of land-based fighters, their use was discontinued when sufficient aircraft carriers became available to escort convoys all the way across the Atlantic.

The increase in the number and size of the aircraft using the aerodrome, combined with the soft surface, necessitated the laying of a wire netting runway over a base of coir. Known as Sommerfield Track, it formed a 1,450-yard runway which came into use in February 1942.

The nearby port of Greenock was the starting point for many Atlantic and Arctic convoys, and Abbotsinch housed naval air squadrons while their aircraft carriers were tied up on the Clyde. The aerodrome was transferred to the Fleet Air Arm on 11 August 1943 and became HMS *Sanderling*. Whoever gave it its name obviously had a sense of humour – the sanderling is a small wading bird that lives in marshy areas!

Despite the laying of the Sommerfield Track, the runway was still

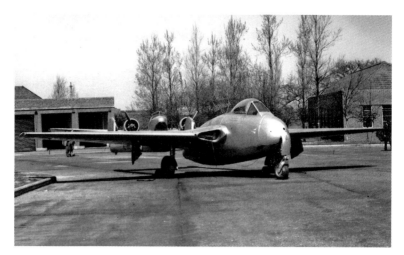

No. 602 Squadron entered the jet age with the introduction of the Vampire FB.5. (Author)

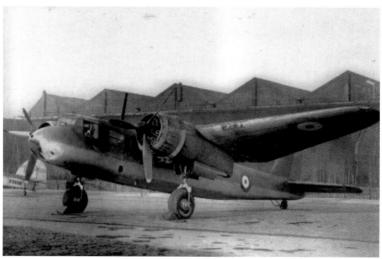

One of the 580 Blackburn Botha I reconnaissance/torpedo bombers, 200 of which came from Blackburn's Dumbarton factory and were test flown from Abbotsinch. Among its many faults, the aircraft was seriously underpowered. (Author)

soft, and any aircraft running off it quickly became stuck fast, so in 1950 tarmac and concrete runways were laid over a foundation of rubble from the Glasgow Blitz. During the construction, it is said that a steam roller, left on the aerodrome one night, sank in the soft ground!

The aerodrome is probably best remembered for the Aircraft Holding Unit, which was responsible for the storage and scrapping of hundreds of surplus naval aircraft. In 1959–60, for example, there were 400 Sea Hawks, Sea Venoms, Avengers and Skyraiders parked up awaiting their fate.

When the Navy left on 31 October 1963, they presented the station's White Ensign to Paisley Abbey, and the 'ship's' bell to the new airport, where it was hung in the aptly named Sanderling Bar in the main terminal.

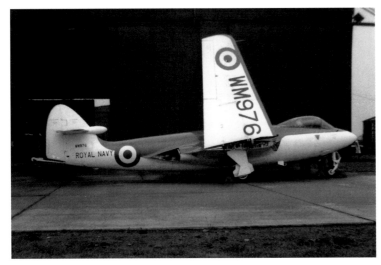

Hawker Sea Hawk
FB.3 WM976.
(Author)

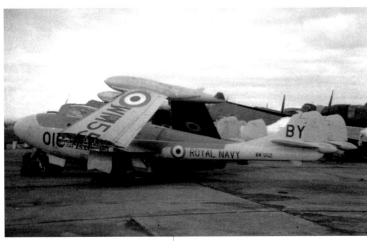

De Havilland Sea
Venom FAW.20
WM552. (Author)

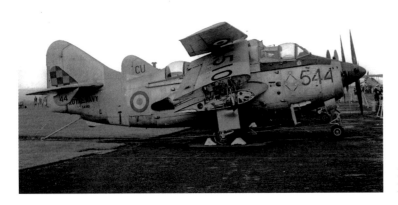

Fairey Gannet AS.1
XA510. (Author)

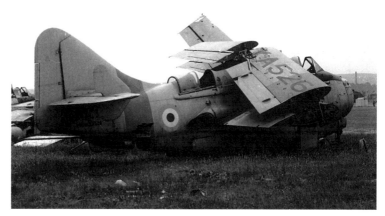

Fairey Gannet T.2 XA526. (Author)

Fairey Gannet AS.1 WN392. (Author)

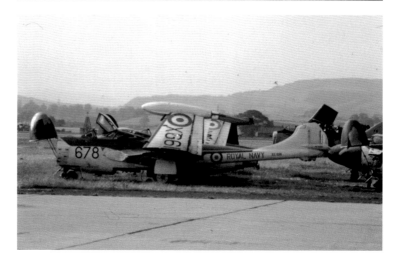

De Havilland Sea Venom FAW.21 XG618. (Author)

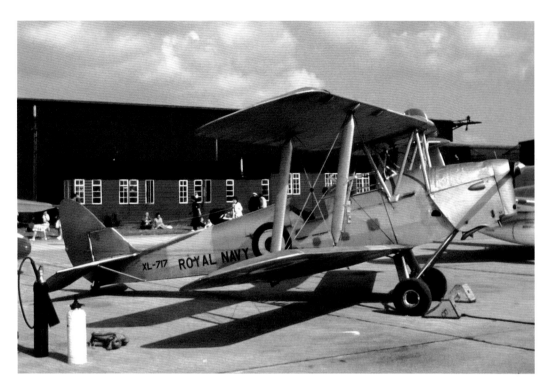

De Havilland Tiger Moth XL717, seen at an open day at HMS *Sanderling* on 7 July 1962. She is now preserved at the FAA Museum, Yeovilton. (R. A. Scholefield Collection)

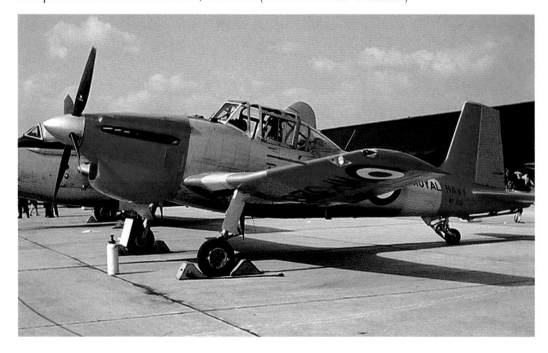

Boulton-Paul Sea Balliol T.21 WP328 served with the Maintenance Test Pilots School at HMS *Sanderling* before being retired in 1963. (R. A. Scholefield Collection)

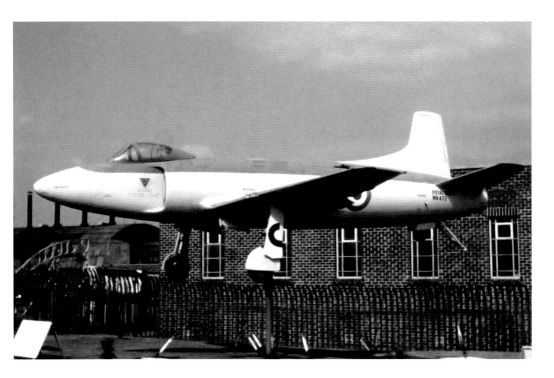

Supermarine Attacker F.1 WA473 was mounted on a pole in 1957 as the gate guardian at HMS *Sanderling*. Taken to the FAA Museum, Yeovilton, in 1963 for restoration, she is now on permanent display. (R. A. Scholefield Collection)

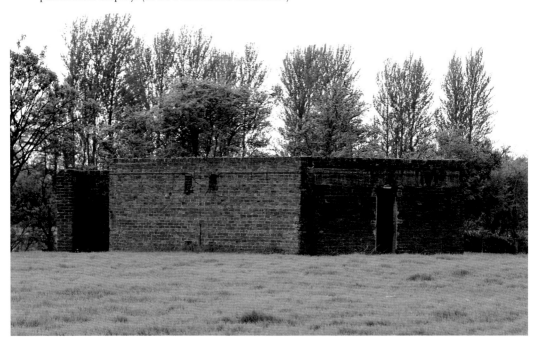

Seen in May 2014, this building, located just outside the north-western boundary, is one of the few reminders of the aerodrome's wartime past that still remain. (Author)

Glasgow International Airport

Some thirty airlines fly to almost one hundred destinations from Glasgow airport; it is Scotland's principal long-haul gateway, in addition to being the hub for the Highlands and Islands, and is one of only seven UK airports with flights to Heathrow.

Until recently, the airport was owned and operated by Heathrow Airport Holdings, formerly known as British Airport Authority, but in October 2014, along with Aberdeen and Southampton, it was sold to Madrid-based Ferrovial and Sydney-based Macquarie in a £1 billion deal.

Passenger operations are focussed around two terminals, with cargo and maintenance facilities based to the east, and other ancillary facilities to the west of them. Since 1966 the main terminal has undergone almost continuous internal alterations and improvements in response to increasing passenger numbers and evolving security requirements, all at no cost to the taxpayer, but unfortunately, this remodelling has resulted in the original public viewing areas ending up airside, making the airport now inaccessible to aviation enthusiasts and spectators.

The two terminals provide a total of sixty-three check-in desks, with hold baggage screening systems and nineteen self-service check-in kiosks. All departing passengers use a single security search area, known as the 'Skyhub', and there are three domestic and four international baggage reclaim belts.

There are three piers: 'West' pier caters for international traffic; some gates on this pier are capable of handling Boeing 747 and 777 aircraft, the largest currently using the airport. The 'Central' pier is used for domestic destinations – British Airways' Heathrow and Gatwick shuttles and Flybe comprise the majority of its traffic, and the BA Executive Club lounge is situated at the end of this pier. The 'East' pier, which was originally used for international flights, has been redeveloped for use by easyJet, Loganair (currently franchising using Flybe) and Aer Lingus. None of the stands on this pier are provided with air bridges.

Flybe de Havilland Canada DHC-8-402Q Dash 8s G-ECOJ and G-ECOY lined up along the domestic pier. (Dr Bartolomeo Gorgoglione Collection)

Originally delivered to British Midland as G-BMAJ, this British Airways Express Short 360-100 was re-registered as G-WACK, and served with Manx Airlines before moving to Loganair, as seen here. The base of the east pier can be seen in the background. (R. A. Scholefield Collection)

Tarom Ilyushin Il-18D YR-IMH in front of the east pier. She crashed in the Carpathian Mountains on 14 August 1991. (Bill Crookston Collection)

There are forty-four parking stands on the three piers, forty of which are 'contact' – located immediately adjacent to the terminal piers – while the remainder are 'remote' from the terminal, and passengers are transferred to and from them by bus.

The airport has a busy cargo facility that covers 6 acres and is composed of a mixture of cargo units and logistics warehousing, served by a dedicated cargo apron. The cargo business is made up of two elements: that flown on passenger services (known as belly-hold); and that flown on dedicated cargo flights. Abbotsinch is an important hub for cargo sent to major freight airports such as Heathrow and Stansted by road.

The only runway, 05/23, is 8,720 feet long and is aligned south-west/north-east, into the prevailing wind. Equipped with a Category III Instrument Landing System (ILS), it can accommodate up to thirty-two traffic movements per hour, thirty-six in extremely busy periods. The much shorter, and little used, Runway 09/27 was closed in 2008.

The airport follows the strict Department of Transport day/night noise restrictions, which are legally required at large airports, but which have been adopted on a voluntary basis by Glasgow. Noisier aircraft (known as 'Chapter 2 aircraft') are banned, and differential landing charges encourage airlines to operate quieter types. In addition, a noise and track keeping system continuously monitors aircraft; in line with International Civil Aviation Organization standards, if the noise limit is breached, the airline is fined, and the money is allocated to the airport's community fund. There is even a dedicated telephone number on which the public can register a noise complaint. Night-time flying is kept to a minimum and is usually undertaken by the quieter turboprop

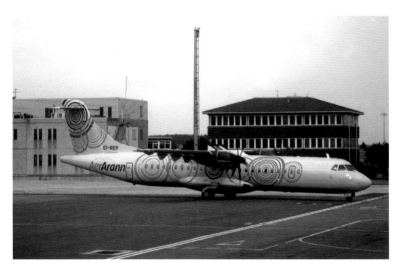

Aer Arann ATR 72-500 EI-REP. (Dr Bartolomeo Gorgoglione Collection)

aircraft – in 2012, for example, less than 3,000 of the 71,000 traffic movements occurred between 2300 and 0600 hours, which equated to 4 per cent of the annual flights.

The air traffic control tower, built in the late 1940s, is located between the main runway and apron area, and the airport has invested heavily in state-of-the-art surface movement and primary surveillance radar systems to improve the safety and efficiency of air traffic movements.

The dedicated maintenance area occupies 8 acres to the east of the main terminal; the largest hangar is used by British Airways for their fleet of Boeing 737 and Airbus A300 aircraft and employs over 200 engineers. A smaller hangar, 25,000 sq. ft in size, provides similar facilities for Loganair, and is conveniently situated adjacent to the airline's head office.

The airport is the size of a small town, and consequently requires numerous ancillary facilities to support its operation – among other things it has its own fire service, chaplaincy, supermarket, police station and roads system. A £4-million project in 2010 improved passenger pick-up and drop-off facilities and has led to less congestion and fewer emissions. There are four parking areas within the airport, offering a total of 6,190 spaces; in addition there are also 1,494 staff car parking spaces on the campus.

Some of the key ancillary facilities include a fire station manned twenty-four hours a day; a fuel farm that covers 4 acres and holds 77,000 gallons of Jet A1 aviation fuel in seven tanks; a general/business aviation area; in-flight catering units; aircraft sanitation unit; motor transport facilities; engineering workshops and snow base; contractors' compounds; office accommodation; police station; taxi feeder rank; petrol filling station; nursery and flying club.

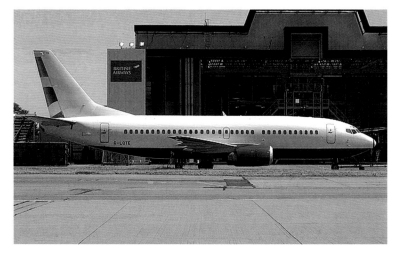

Boeing 737-3Y0 G-LGTE in front of the British Airways maintenance hangar. Note the partial BA livery. She first flew in 1991 as TC-SUP with Sun Express, and was delivered to British Airways in December 2000. Since leaving BA she has flown as N908BV with Aer Cap and as PR-WJT with Webjet Linhas Aereas. (Iain Mackenzie Collection)

Maintenance on the starboard engine in the British Airways maintenance hangar. (Bill Crookston Collection)

The 25,000 sq. ft Loganair hangar. (Author)

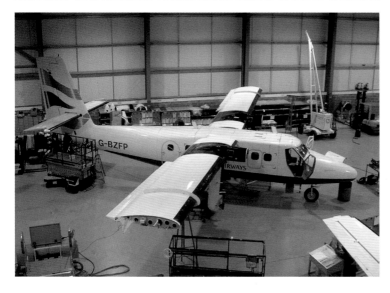

Loganair de Havilland Canada DHC-6 Twin Otter G-BZFP undergoing maintenance. She was involved in a landing incident on 22 March 2007 – see the 'Incidents' chapter. (Scott Bannister Collection)

The UK, as a signatory to the 1944 Chicago Convention, is required to operate its airports in accordance with specific internationally agreed criteria. Responsibility for ensuring compliance with these criteria resides with the Civil Aviation Authority. Air Navigation Order 2000 requires that flights in the UK for the public transport of passengers, or for the purposes of flying instruction, take place at a licensed aerodrome. Glasgow is a licensed aerodrome, but to retain this status it has to continually adhere to CAA standards, which are subject to ongoing revision to reflect changes in the industry.

There are car-hire desks in domestic arrivals, with dedicated pick up/drop off, washing, fuelling facilities and offices nearby, while three hotels on the airport campus (Holiday Inn, Express by Holiday Inn and Travel Inn) have a total of 550 rooms available.

The airport supports more than 7,300 jobs across Scotland, and is the largest private sector employer in Renfrewshire; it also contributes nearly £200 million to the economy.

The Airport's History

The Beginning

By 1960 it was apparent that Glasgow's original airport at Renfrew was too small to accommodate the growing number of passengers and the increasing size of aircraft, and as urban encroachment prevented its expansion, Glasgow Corporation decided that a new airport was required – the obvious choice was Abbotsinch, situated 2 miles to the west.

Representations were made to the Government, and on 14 November 1960 the then Minister of Aviation, Peter Thorneycroft, announced that RNAS Abbotsinch was to be developed as the new Glasgow airport, but with one important caveat. Prestwick airport was to remain as the preferred transatlantic airport, and consequently Glasgow would only cater for domestic and European flights. Glasgow Corporation was initially reluctant to take ownership of the airport, but following Government pressure it paid £2.5 million of the £4.3-million construction cost, in addition to £250,000 for purchase of the land and £80,000 for equipment transferred from Renfrew.

Initially Renfrew's terminal was to be rebuilt at Abbotsinch, but it was too small, so the renowned Scottish architect Sir Basil Spence OBE designed a new terminal building in the Brutalist style – an austere style of architecture with an emphasis on poured concrete. His most famous work is the replacement for the fifteenth-century Coventry Cathedral, which was destroyed by bombing during the Second World War.

He later commented:

> On our first visit to Abbotsinch we were fortunate that it was a beautiful day and the view down the runway to the hills beyond revealed one of the great attractions of the site which is almost unique in this country, and even abroad, where airports are normally situated on uninteresting flat land. This presented the opportunity for a design which helped the traveller to feel the adventure of flying from this particular airport.

The original Sir Basil Spence-designed terminal building. Built in the Brutalist style, the barrel-vaulted roof is clearly visible. (Author)

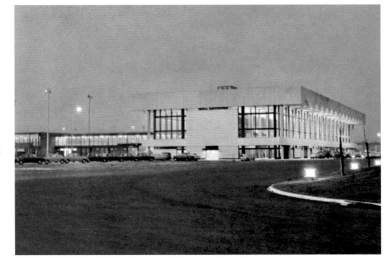

Inside view of the original terminal; note the barrel-vaulted roof and original BEA check-in desks. (Author)

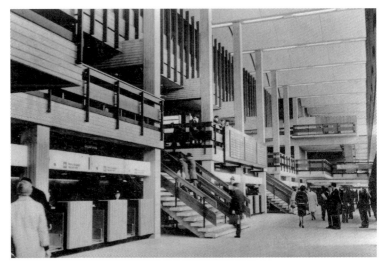

Inside view of the original terminal. (Author)

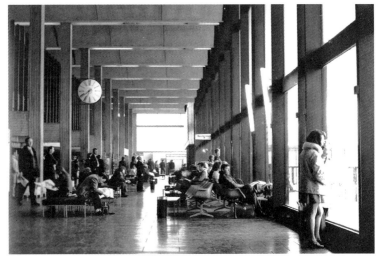

The east pier and control tower. (Bill Crookston Collection)

The first aircraft to land arrived on 26 April 1966, when the crew of RAF Percival Pembroke WV703 mistook Abbotsinch for Renfrew. At 8 a.m. on 2 May 1966, the first scheduled flight arrived, from Edinburgh; it was the British European Airways Viscount G-AOYP, flown by the company's Scottish Flight Manager, Captain Eric Starling, carrying sixty-four members of Sir Basil Spence's staff. The first commercial flight, BEA Herald G-APWB from Aberdeen, landed at 0821, and the first departure was Heron G-ANXA.

Glasgow's new airport was officially opened on 27 June 1966 by Queen Elizabeth II, but instead of the usual plaque, she unveiled a window looking on to the apron, on to which the dedication details had been etched.

1960s

Ex-Second World War bomber pilot Ronald A. Read DFC was the new airport's first director, and under his leadership in the first three months, the airport handled 400,000 passengers and 17,000 aircraft movements. The one millionth customer was transported on 20 December, and by the end of the first year the figure stood at 1.5 million passengers and 34,300 flights.

One of the first routes for Abbotsinch was inaugurated on 2 May 1966, when BEA commenced a twice-daily service to London with de Havilland Comet 4B G-ARJN. The first year saw 654 different aircraft types use the airport – every week there were more 'firsts', but there was also a notable 'last'. When BEA's Handley Page Herald G-APWD touched down on 31 October from Islay and Campbeltown, it brought to an end the airline's association with the aircraft.

British Island Airways Handley Page Herald G-APWG. (Don Stirling Collection)

In June 1967 twenty-five airlines put forward the idea that Abbotsinch should be renamed Glasgow Meldrum after Sir James Meldrum, Lord Provost of Glasgow, who had been instrumental in the development of the airport. Over the years several alternative names have been suggested, but thus far none have been acted upon.

Despite the caveat issued when the creation of Abbotsinch was announced, by 1968 the airport had begun pressurising the Government to relax its Scottish Lowland Airport Policy, and to allow transatlantic flights to use Glasgow. However, the newly introduced Boeing 707 was better suited to Prestwick's longer runway; that at Abbotsinch was marginal, at 6,720 feet, if the aircraft was fully loaded for a trip across the Atlantic. The pressure was maintained, but it took a further twenty years and legal action before the policy was changed.

When Britannia Airways Boeing 737 G-AVRM *James Watt* made a textbook arrival at Abbotsinch on 14 October 1968, little did anyone realise that almost fifty years later Boeing 737s would still flying in to and out of the airport.

1970s

In the late summer of 1970, a new generation of passenger jet appeared in the skies over Abbotsinch. BOAC Boeing 747-136 G-AWNC made two ILS (instrument landing system) approaches, one a low fly-by, the other a touch and go, but the runway was not considered to be of adequate length. Consequently, just four years after opening, the airport embarked on an upgrade programme which continues to this day as it strives to keep pace with the developments in aircraft technology.

KLM Douglas DC-9-15 PH-DNB *City of Brussels*. (Don Stirling Collection)

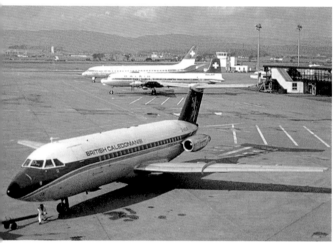

BAC 111-201AC G-ASJE *City of Dundee* was the fifth production 111, and first flew on 5 May 1964. Seen here in British Caledonian livery, she had previously been owned by British United Airways, and later flew with Braniff Airways as EI-BWJ, and with Cascade Airways and Pacific Express as N102EX. (Don Stirling Collection)

Thick exhaust smoke trails from Britannia Airways Boeing 737-200 G-AVRM *James Watt* as she approaches Abbotsinch on 14 October 1968 to become the first of her kind to land at the airport. Almost fifty years later, 737s are still flying in and out daily. It is the bestselling commercial airliner in the history of aviation – almost 8,000 had been built by the end of 2013, with orders for almost 3,500 more. It is estimated that at any given moment there are 1,250 737s in the air, and that two either land at or depart from an airport every five seconds. (Bill Crookston Collection)

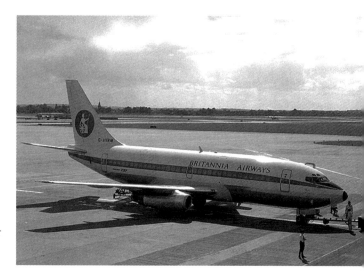

Boeing 737-200 G-AVRM *James Watt* was the second 737 in the Britannia Airways fleet, and has the short engine nacelles that were found to cause drag. She later flew in the USA with Presidential Air, Key Airlines and America West Airlines, but was written off on 30 December 1989 in a landing incident. (Michael West Collection)

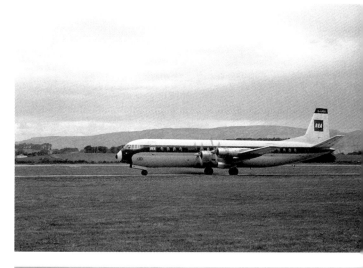

Vickers Vanguard G-APEA *Vanguard* was the first of BEA's twenty Vanguard Class aircraft, although none carried their name on the fuselage. She served with BEA between March 1961 and January 1973. (Bill Crookston Collection)

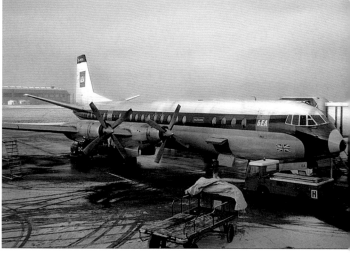

Vickers Vanguard G-APEA *Vanguard*. She was the largest airliner flown by BEA until the introduction of the Trident 3 during the early 1970s. This aircraft flew the Glasgow–London route in eighty-five minutes, and a ticket cost £6 11s 0d. (Dan Clark Collection)

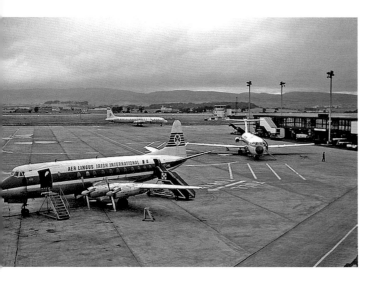

Vickers Viscount EI-AKL *St Colmcille* served Aer Lingus between March 1959 and March 1970, before being sold to Air Commerz as D-ADAM. (Paul Thallon Collection)

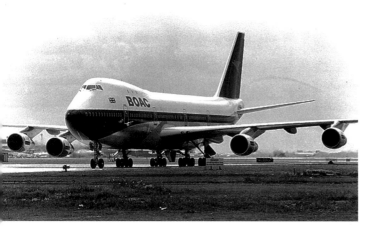

BOAC Boeing 747-136 G-AWNC was the first of her kind to appear over Abbotsinch. Delivered on 29 June 1970, she flew a series of proving flights to UK airports, including an ILS low approach and overshoot at Abbotsinch on 1 August 1970. Two weeks later she was the first 747 to land at Manchester. Sold to Air Gulf Falcon in 1999 and registered as P4-GFA, she was scrapped in 2005, just over thirty years after her maiden flight. (Michael West Collection)

On 26 April 1972 the Red Arrows arrived in their distinctive Folland Gnats and gave a spectacular display during their pre-season tour. Unfortunately it was rather too good, and in the eyes of a few, the disruption they caused was unacceptable; it resulted in a court injunction preventing them from performing again three days later during the University Air Squadron's 'Scone Trophy' competition!

During the early summer of 1972, all flights were temporarily diverted to Edinburgh while the runway was resurfaced and extended and a Category III ILS installed, making Glasgow the second, after Heathrow, to have this system. The runway reopened on 29 June, having been increased in length from 6,720 to 8,419 feet to accommodate the latest wide-bodied aircraft. The first Lockheed Tristar – N305EA – landed on 17 September, and Laker Airlines DC-10 G-AZZC *Eastern Belle* arrived on 24 November.

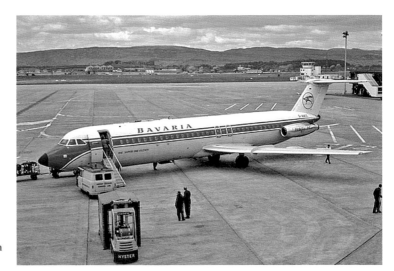

Bavaria
Fluggesellschaft
BAC 111-528FL D-
AMUC. (Paul Thallon
Collection)

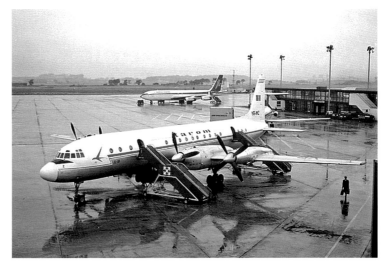

Tarom Ilyushin
Il-8D YR-IMZ. (Paul
Thallon Collection)

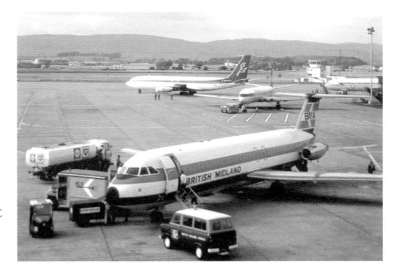

British Midland BAC
111-523 FJ G-AXLL.
(Don Stirling
Collection)

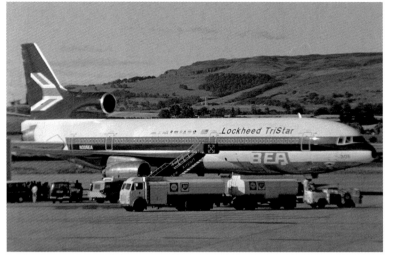

BEA Tristar N305EA, Lockheed's demonstrator aircraft, during its world tour. The aircraft was taken from the assembly line, and her Eastern Airlines livery was overlaid with the BEA 'Speedjack' design. (Bill Crookston Collection)

The oil crisis of 1973/74 led not only to a downturn in passenger numbers, but also to a scaling down of plans for the airport – most notably, a planned star-shaped terminal for wide-bodied aircraft was cancelled. Despite the dip, however, Abbotsinch welcomed BOAC's Boeing 747-136 G-AWNM – the first Jumbo to land – on 15 May 1974. The amalgamation of BOAC and BEA created British Airways, and aircraft wearing its livery began to appear on the apron during the second half of 1974.

Although it appeared to be thriving, the oil crisis and labour disputes contributed to Abbotsinch accruing debts of £6.75 million. Clearly, Glasgow Corporation could not absorb such losses, and on 6 September 1974 it struck a deal to sell Abbotsinch to the British Airports Authority, who not only covered the debt, but also paid Glasgow Corporation a further £1 million. The change of ownership on 1 April 1975 also saw the formation of the Scottish Airports Division of BAA at Abbotsinch to administer Glasgow, Prestwick, Edinburgh and Aberdeen.

On 12 January 1975, just prior to the takeover, British Airways Trident 1 G-ARPC flew the inaugural Heathrow–Glasgow Shuttle. First suggested by BEA in 1962, the idea was simple; there was no pre-booking, passengers simply turned up on the day and were guaranteed a seat, even if that meant flying a second aircraft with just one passenger on it – they could even pay on board, just like on a bus! By the end of the first week, over 10,000 people had used the service and in September 1975 alone over 64,000 passengers were carried.

At the end of 1975 a new round of improvements began in the terminal, which lasted to the end of the decade. The original building was almost ten years old, and struggling to cope with the ever

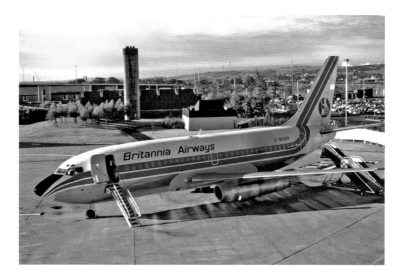

Britannia Airways
Boeing 737 G-BADP.
(Bill Crookston
Collection)

Dan-Air de Havilland
Comet G-APMF
William Finlay was a
stretched 4B version,
one of fourteen
built for BEA in
1959. (Don Stirling
Collection)

British Airways
Hawker Siddeley
Trident 2E G-AFVD.
(Don Stirling
Collection)

BAC 111-208AL EI-ANH *St Ronan* was one of four of this model that flew with Aer Lingus between September 1965 and February 1991. She was sold to Hold Trade Air in Nigeria as 5N-HTB, but was written off in a crash in April 1993. (Paul Thallon Collection)

British Airways Hawker Siddeley Trident G-ARZZ. (Bill Crookston Collection)

increasing passenger numbers. A prefabricated metal frame was wrapped around the front of the terminal, and a glass atrium and walkway connected the two, but unfortunately this obscured much of Basil Spence's original building, and the distinctive barrel-vaulted roof could only be seen from airside. Alterations to the roof also necessitated the temporary closure of the spectators' terrace, a portent of what the future held. Finally, construction of a new European pier increased the overall number of aircraft stands to thirty-eight, and passenger capacity to 9 million.

By 1976, increased traffic at many airports, including Glasgow, began to generate complaints about noise, a difficulty that continues to this day. Grants were made available to householders affected in order to soundproof their homes, and jet traffic movements were kept to an absolute minimum between the hours of 2330 and 0630.

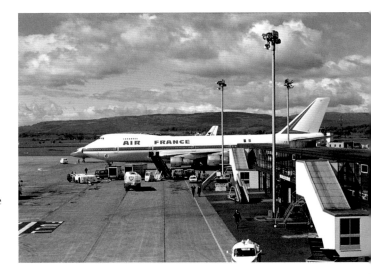

Air France Boeing 747-128 F-BPVF brought Saint-Étienne fans to Glasgow for their 1976 European Cup Final against Bayern Munich. (Bill Crookston Collection)

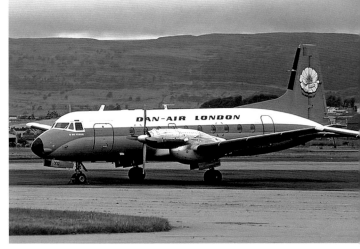

Dan Air Hawker Siddeley HS-748 Srs.2A-275 G-AYYG, still in the livery of Mount Cook Airlines of New Zealand, her previous operator. She was later converted to a freighter, flying with Emerald Airways as G-SOEI, and is currently registered as N748D. (Paul Thallon Collection)

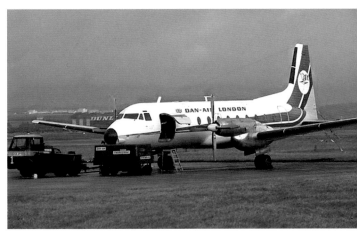

Dan-Air Hawker Siddeley HS-748 Srs.1-101 G-ARMW being serviced at the old executive apron. She also flew with Skyways International, Northeast Airlines and Aberdeen Airways as G-ARMW, then British Independent Airways as G-FBMV, and finally as 9N-ACH with Necon Air, Nepal, and now lies derelict at Kathmandu Airport. (Brian Hill Collection)

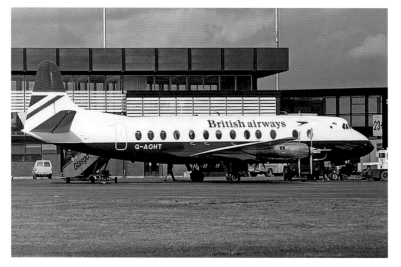

Delivered to BEA in June 1957, Viscount G-AOHT also flew with British Airways, Virgin and British Air Ferries before being scrapped in 1991. (Paul Thallon Collection)

1980s

The recession of the early 1980s had a dramatic effect on passenger numbers throughout the UK; at Glasgow they dropped by 3.3 per cent in 1980 and a further 1.3 per cent in 1981, to 2,296,138. Conversely, however, during the same period the amount of freight carried increased to 12,700 tons.

Despite the downturn, BAA continued to upgrade the airport. On 24 March 1981 the main runway was redesignated 05/23 due to a change in the magnetic variation and from April it was closed to night flying for several weeks to allow the airfield lighting to be renewed. As previously mentioned, the issue of noise pollution was, and always is, simmering away in the background, and this lack of night-time operations led some local residents to call for a permanent ban. A petition was raised, and a public meeting called; however, it became clear that the overriding majority of people were in favour of twenty-four-hour operation, especially following assurances by the airport concerning noise abatement procedures, and the call for an outright ban was dropped.

On 11 October 1981 there was a double 'first'. Concorde, G-BOAG, arrived on her debut fare-paying domestic flight. Interestingly, despite the ongoing debate about noise, not one complaint about Concorde was received by the airport – and on climb out she was not inaudible; living beneath the flight path, 3 miles from the end of the runway, the author can readily vouch for that! But such a graceful bird was easily forgiven.

As the recession began to ease, so passenger numbers began to increase, and by the end of 1982 some 2.4 million people had used the airport during the year. A new program of improvements followed, which saw the repositioning of the information desk, tour operators' desks and ticket desks in order to extend the number of landside shops

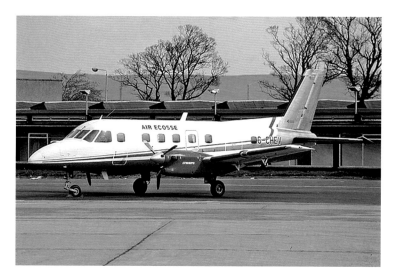

Air Ecosse Embraer
EMB-110P2
Bandeirante
G-CHEV. (Paul
Thallon Collection)

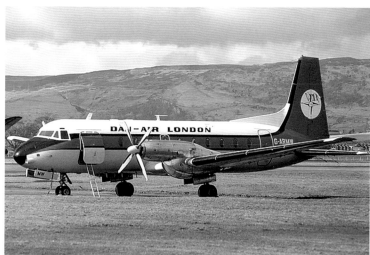

Dan-Air Hawker
Siddeley HS-748
Srs.1-101 G-ARMW.
(Brian Hill
Collection)

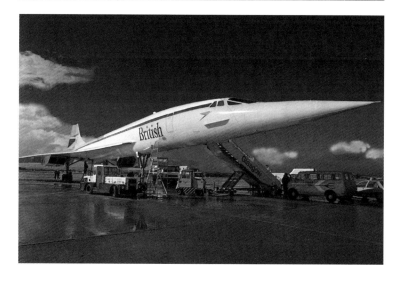

BAC Concorde
G-BOAG, seen on
11 October 1981
on her first visit
to Abbotsinch.
(John Macintyre
Collection)

to better cater for the increased footfall. Work commenced on 1 May 1983, and a month later a major upgrade of the airfield infrastructure also began. Airside, two stands on the domestic pier were resurfaced, and as a trial had fixed power units installed. These were connected to the aircraft while they were on the ground to provide electricity for air conditioning and other on-board systems so as not to drain the aircraft's own batteries. Landside, a new short-term car park was constructed in front of the main terminal. The main upgrade of 1983, however, was to Taxiway Alpha. It runs parallel to Runway 05/23 and was increased in width from 59 to 75 feet; it was also strengthened to accommodate larger and heavier aircraft. Completed in May 1984, the first aircraft to use the new £1.75-million taxiway was an Iberia 747.

The year 1983 was also a busy one for special visits. On 7 July the airport was treated to a low pass by an unusually configured Boeing 747. The NASA aircraft, N905NA, was returning to the United States following an appearance at the Paris Air Show, and was carrying a very special passenger – the space shuttle *Enterprise*.

British Midland had begun to offer its 'Diamond Service' (low-fare prices that included food and drink) on flights to London, in direct competition with the British Airways Glasgow–London Shuttle. In response, British Airways relaunched its shuttle service on 30 August by rebranding it 'Super Shuttle'. No expense was spared by the publicly owned company, and no fewer than three Concordes arrived at Abbotsinch on the day – G-BOAA, G-BOAB and G-BOAD. While tickets could no longer be purchased on board, food and drink was included in the price; this service lasted until the end of the decade, after which it returned to the standard 'Shuttle'.

Nine years after BAA took over, the airport finally reported its first trading profit – £2.5 million in 1983/4. The increase in passenger numbers – some 2.47 million in 1983 – and consequent increase in aircraft movements proved a double-edged sword, however, as by 1985 Runway 05/23 was wearing out. Between 14 June and 18 October of that year, the runway was closed five nights a week while it was resurfaced at a cost of £3.5 million.

The winter of 1983/84 was particularly bad, and during January 1984 the airport was closed on no fewer than twelve separate occasions, making it the worst period of disruption since it opened in 1966.

In line with predictions, passenger numbers continued to grow, from 2.8 million in 1984 to over 3 million by the end of the decade, as did cargo, which amounted to almost 16,000 tons by 1989. To accommodate the increase, two more refurbishment programs were completed before 1990. The first began in 1984 and saw a new information desk

Spantax Convair 990A EC-BZO was put into open-air storage at Palma airport when the company folded in 1987; she awaits restoration. (Alistair Bridges Collection)

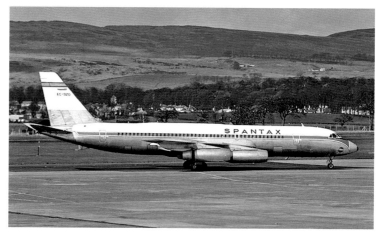

Seen in June 1983, five months after being delivered, Boeing 757-236 G-BIKB still has incomplete British Airways livery. Sold to DHL Airlines in October 2001 and converted to a freighter before moving to European Air Transport in 2002 as OO-DPF, she is currently flying in EAT Leipzig livery as D-ALEB. (Alistair Bridges Collection)

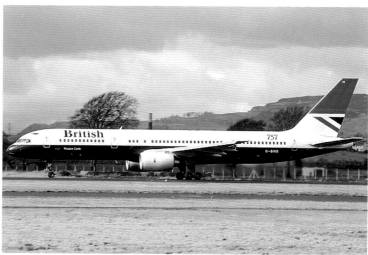

This Boeing 707-338C first flew on 29 December 1966, and during a long and distinguished career flew with Qantas; ATASCO; British Midland Airways (as seen here as G-BFLE); Ariana Afghan; Somali Airlines; Gulf Air; El Al; Linhas Aereas de Mozambique; Pakistan International Cargo;

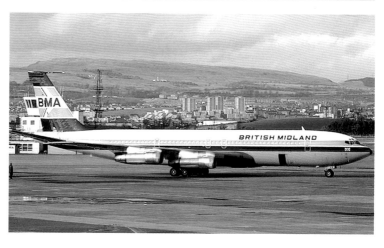

Southern Air Transport; and Air Algérie. She then served as a test-bed for the E-8 program with Grumman Aerospace as N2178F, and was converted to E-8C standard; she now flies with the US Air Force as 94-0284. (Alistair Bridges Collection)

being created, while the domestic lounge had a facelift, and behind the scenes, the outbound luggage sorting area was redesigned to take account of the vast amount of luggage now being handling. The autumn 1985 extension to the international pier was modest, costing a mere £2 million, and saw the departure lounge refurbished and a new duty-free shop, catering and bar facilities created.

In 1987, British Airports Authority was privatised and renamed BAA, and at the same time it sold Prestwick – as it turned out, rather fortuitously. Government policy was still unchanged; all transatlantic flights were to be operated from Prestwick, and as successive administrations had pumped millions into the facilities there, despite numerous requests and attempts, there were no plans to change this – until 1989, that is. The change came about when the policy was challenged in the courts, but it was not the airports who brought the case; it was a new airline – Air 2000 – who had based one of its Boeing 757s at Abbotsinch from 1988. Against all the odds, the Manchester-based airline won, as a result of which Glasgow airport would profit handsomely.

1990s

On 6 March 1990, the then Secretary of State for Transport, Cecil Parkinson, announced the change to the Scottish Lowland Airport Policy in response to the Air 2000 court ruling. From 1 May 1990 there was to be an 'Open Skies' policy, allowing airlines to apply for routes to whichever of the three Scottish airports suited their market. Northwest Airlines and Air Canada lost no time in transferring their services to Abbotsinch; Northwest flew their first direct transatlantic

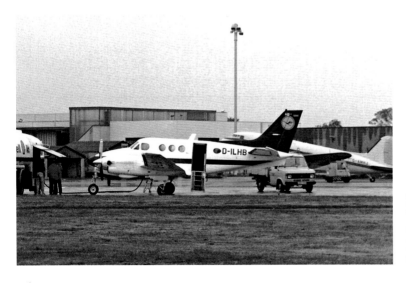

Lufthansa Flight Training Beechcraft C90 King Air D-ILHB. (Neil Russell Collection)

Euroair Hawker
Siddeley HS-748
G-VAJK. (Neil
Russell Collection)

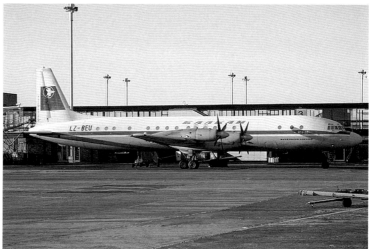

Bulgarian Airlines
Ilyushin Il-18V
LZ-BEU. (Alistair
Bridges Collection)

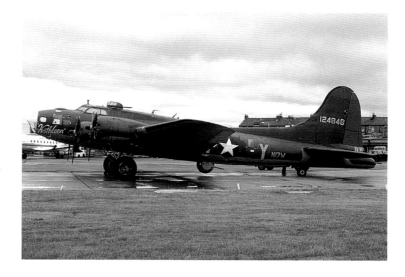

An unusual visitor
in August 1989 was
Kathleen, B-17F
N17W 124848 DP-Y.
She was returning
to the USA after
appearing in the
film *Memphis Belle*.
(Alistair Bridges
Collection)

flight, DC10 N149US, on 2 May, while the first Air Canada flight, Boeing 767 C-GDSP, touched down on the 16th. BA commenced its Tristar service to New York on 3 August with G-BEAK.

As a consequence of the new policy, the first thing to change was the name – Abbotsinch now became known as 'Glasgow International Airport'. BAA also embarked on a massive redevelopment programme. The footprint of the terminal building was increased by 70 per cent, costing £55 million, which raised passenger capacity from 5 million to 10 million per year. A £1-million supplementary check-in facility opened in October 1990, and the first stage of the redevelopment was officially opened by Her Royal Highness Princess Anne on 15 June 1992. The second stage of the development consisted of a new £40-million international pier, designed to accommodate eight wide-bodied aircraft; an international departure lounge; and a combined baggage arrivals/immigration hall. The new pier opened on 17 November 1994 and included a new state-of-the-art security screening system designed to detect explosives in hold baggage. Following its successful deployment, the same system was installed at Heathrow.

Despite the state-of-the-art facilities, the airport could still be brought to a standstill by minor incidents. On 23 December 1993, United Airlines Boeing 767 skidded off Runway 23 in icy conditions, and her wheels sank in the notoriously soft ground, closing the runway for four hours while maintenance crews tried to free her. Runway 09/27 was de-iced to allow smaller aircraft to continue operating until the blockage was cleared.

On 10 November 1995, a Boeing 737-200 took off to fly to Luton, but this was no ordinary flight – the era of the low-cost airlines had arrived. In just over twelve months, easyJet had increased its number of flights to five each way per day.

In 1996, over 5.5 million passengers passed through Abbotsinch, making it the fourth-busiest UK airport, and by 1999 it was handling 7 million. The decade ended as it began, when Runway 05/23 was strengthened and resurfaced and the ground lighting was realigned. The work was undertaken at night between 1 November and 31 March 2000, and during this time there were restrictions on runway length. The STOL characteristics of the Britten-Norman Islanders on the Highlands and Islands routes came into their own at this time – they used a 500-yard-long strip on Taxiway Alpha.

The New Millennium

The first traffic movement of the year 2000 was the Scottish Air Ambulance, Loganair Islander G-BLNW, just twenty minutes into the new millennium. However, the events in America on the morning of

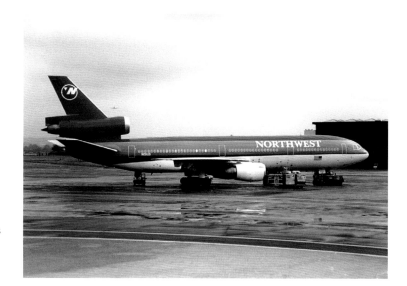

Northwest Airlines
McDonnell Douglas
DC-10-40 N151US.
(Neil Russell
Collection)

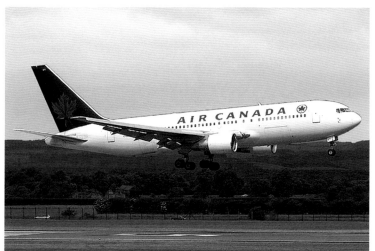

Delivered to Air
Canada in October
1984, Boeing 767-
233-ER C-GAVC was
later re-registered
as N749JM with Jet
Midwest, before
being put into
storage in the
Mojave Desert.
(Alistair Bridges
Collection)

British Air Ferries
Viscount G-AOYN
is pictured where
the terminal now
stands. Owned
by BAF between
February 1981 and
June 1996, and
re-registered as
G-OPAS in October
1994, she was
broken up for scrap
in early 1997, but her nose section is preserved at the Bournemouth Aviation Museum.
(Brian Hill Collection)

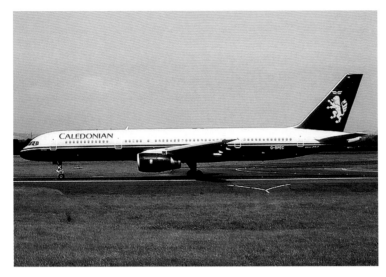

Caledonian
Airways Boeing
757-236 G-BPEC.
(Ian Robertson
Collection)

British Airways
ATP G-BTPE. (Don
Stirling Collection)

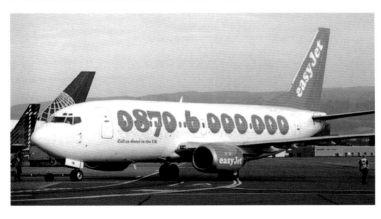

This Boeing 737-3Q8
began life in 1988
with Dan-Air as
G-BNNJ. Service with
British Airways and
Sunjet followed,
before a change
of registration to
G-OCHA. In this
guise she flew
with Excalibur and
Air Europa before
another change
to SE-DTP with
Nordic East then
Eurobelgian Airlines. EasyJet registered her as G-EZYE in 1997, and in 1999 she was sold to
Southwest Airlines, with whom she carries the serial N317WN. (Brian Hill Collection)

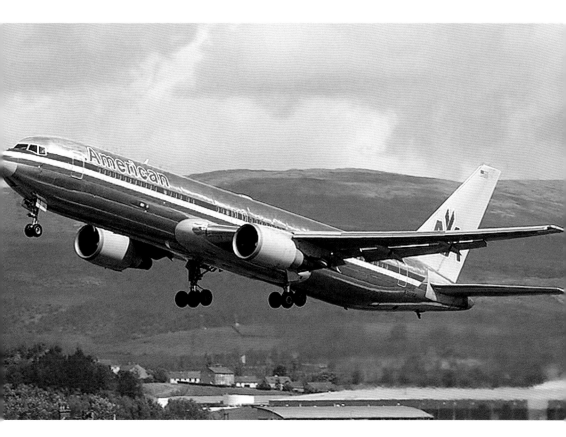

American Airlines Boeing 767-323-ER N362AA. (Alistair Bridges Collection)

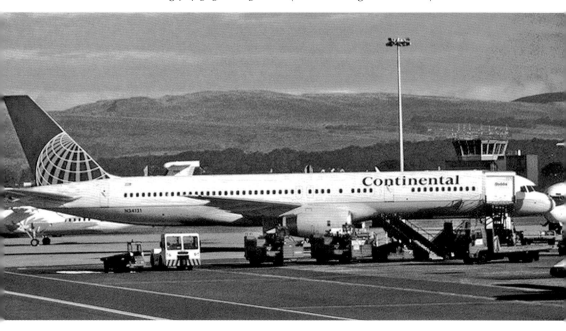

Continental Airlines Boeing 757-224 N34131. (Brian Hill Collection)

11 September changed the whole concept of aviation travel. Although not directly involved in the events of 9/11, four aircraft that were airborne en route to the United States at the time of the incident were diverted to Glasgow when US airspace was closed.

Development work in 2002 saw a £13-million 2,000-space multistorey car park built in front of the terminal, while airside, British Airways opened a £1.5-million hangar, to which it moved its maintenance and engineering facilities for its entire Boeing 737 and Airbus A300 fleet. 'T2' or Terminal 2 – formerly known as the St Andrews Building – was opened in 2003; it housed check-in facilities for EasyJet, Aer Lingus, Virgin Atlantic Airways, Thomas Cook Airlines and Air Scotland. On 10 April 2004, Emirates Airlines commenced a daily long-haul service to Dubai with Airbus A330s, while in July Glasgow became the first Scottish airport to handle 1 million passengers in a month, 1,007,400 to be exact. The strong growth during the remainder of the year allowed BAA to invest in more retail space; they increased the number of shops in the terminal to more than forty and the number of food outlets to fifteen.

Glasgow Airport Rail Link

Glasgow International and East Midlands are the only airports in the UK with no direct rail link, so when Strathclyde Passenger Transport put forward a plan in 2005 to connect the airport to Glasgow Central station it appeared the problem had been solved.

The plan called for an upgrade of 5.4 miles of track between Glasgow and Paisley, and 1.2 miles of new track between Paisley St James and the airport; this would result in a sixteen-minute journey, with four trains every hour between the airport and Glasgow city centre. The original cost was £140 million, but 'red tape' resulted in a slip in the schedule and increased costs, so that by December 2008 the completion date was estimated to be 2013 and the cost £454 million. Then on 17 September 2009, without warning, the Scottish Government axed the project, despite the fact that a major upgrade to the rail line and a new platform at Glasgow Central station had already been completed. Although the project was scrapped, there has still been a considerable cost to the taxpayer – as of February 2014 this is in excess of £40 million.

In June 2005, work began on a £50-million extension to the international pier. Four new stands were added, bringing the total to thirty-eight, while the international arrivals hall was expanded and a giant baggage carousel added to cater for long-haul passengers. Despite the ongoing construction work, a record 1,055,935 passengers passed through the gates in July, the highest monthly figure ever recorded by a Scottish airport, and this was followed by news that 11 August was

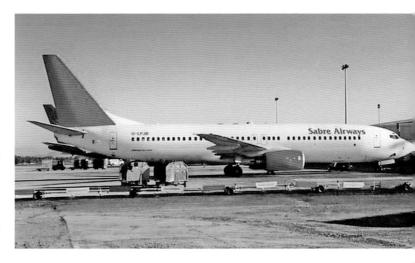

Sabre Airways Boeing 737-81Q G-LFJB also flew as G-XLAC with Excel Airlines and N904MA with Miami Air International before being re-registered as C-FXGG with Canjet Airlines in Canada. (Brian Hill Collection)

Initially delivered to Alitalia as I-DYNI, this McDonnell Douglas DC-10-30 was re-registered as N14062 when she was purchased by Continental in 1984. (Alistair Bridges Collection)

Thomas Cook Airlines Boeing 757-28A G-JMCF and her sisters beneath a leaden Glasgow sky. (Dr Bartolomeo Gorgoglione Collection)

the busiest day in the airport's history, contributing to a total of 8.78 million passengers for the year. On 15 December, Emirates replaced their Airbus A330s with Boeing 777-300-ER aircraft on the Dubai route due to the demand. The new aircraft could carry more passengers and freight on the busy route.

At the end of January 2006, freezing fog grounded many flights, and while the airport carries extensive supplies of de-icer to ensure the runway, apron and taxiways are kept clear, each airline is responsible for de-icing its own aircraft. On 14 March, it was snow rather than fog that grounded flights.

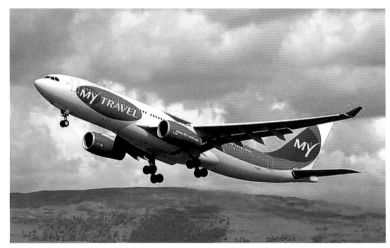

MyTravel Airbus A330-243 G-OMYT. (Alistair Bridges Collection)

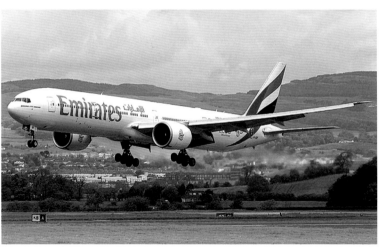

On 15 December, Emirates Airlines introduced the Boeing 777-300ER (Extended Range) aircraft on their Dubai route. Its GE90 engines are the most powerful jet engines in the world, producing more than 115,300 lbs of thrust, the equivalent of 200 Ferrari F360 Modena cars under each wing. They are so big that a Range Rover could be driven through one, and the thrust enables the aircraft, with a maximum take-off weight of 340 tons, to accelerate from 0 to 60 mph in less than six seconds. The 777-300ER measures 242 feet long, with a wingspan of 212 feet, and has a range of more than 7,880 miles. She has a cargo capacity of 23 tonnes, and Emirates SkyCargo moves 1,000 tons of Scottish whisky each year to the Far East, South Africa and Australia. Boeing 777-31H-ER A6-EBF is seen here. (Alistair Bridges Collection)

Air Berlin Boeing 737-76Q D-ABBN first flew in April 2004, but was placed into storage in May 2009 before being re-registered as VQ-BEO in July and operating first with Yakutia Airlines then Alrosia Avia. (Alistair Bridges Collection)

British Airways Avro 146-RJ100 G-BXAS. (Ian Robertson Collection)

De Havilland Canada DHC-8-311Q Dash 8 G-BRYV was delivered to Brymon Airways in 1998 and also served with British Airways CitiExpress, BA Connect (as seen here) and Flybe before being re-registered as 5H-MWG with Air Tanzania. She was written off on 4 September 2009 in a take-off incident at Kigoma airport.

Spanish airline GIRjet was operational between 2003 and 2008. Boeing 757-236 EC-JTN was converted to a freighter in 2009, but is currently held in storage as N597AG. (Daniel Mattsson Collection)

As the airport approached its fortieth birthday in May, plans were unveiled for a £250-million extension. The front of the terminal was to be extended out as far as the car park, thus expanding the check-in area, while the international and domestic luggage claims areas would be amalgamated. The terminal was barely recognisable from that designed by Basil Spence in 1966.

In June, Spanish construction firm Ferrovial won its £10.3-billion bid to acquire BAA, but during the takeover negotiations, the Office of Fair Trading announced an inquiry into competitiveness, raising fears that either Glasgow or Edinburgh airport would have to be sold – as it turned out, it was Edinburgh. The financial dealings had no effect on the passenger numbers, however, which continued to rise – 891,027 in May alone. Football charters also had a major influence on the numbers – in June, for example, 10,000 Celtic fans travelled to Lisbon, while Rangers fans were among some 24,937 passengers who contributed to the busiest day of the month.

EasyJet reached an important milestone on 12 October, when its passenger count reached 10 million since beginning Glasgow operations on 10 November 1995; 1.5 million were carried in 2005/6 alone, with up to 800 people travelling every day.

A record number of long-haul passengers, 38,237, used the airport in January 2007, although by May the total passenger number had dropped to its lowest level for fifteen years, at just under 648,000. The slowdown was blamed on travellers switching to rail services due to increases in air passenger duty, interest rates and additional security measures. In an effort to speed up the security screening process, two new X-ray machines and extra staff were deployed from the end of March, then on Saturday 30 June 2007, the second-busiest day of the year, Glasgow International Airport was the target of terrorists (see the 'Terrorism' chapter).

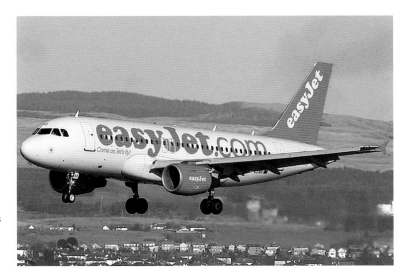

EasyJet Airline Airbus A319-111 G-EZAD. (Alistair Bridges Collection)

Virgin Atlantic launched its first service from Glasgow on 23 June, to coincide with Scottish school summer holidays. Its service to Orlando operated for just a few weeks during the summer, but helped the passenger numbers to bounce back from a dip in June to 970,403 in July. Unfortunately, this was not enough to prevent the airport from losing the title of busiest airport in Scotland. Edinburgh overtook Glasgow in August, despite 8.8 million passengers passing through Abbotsinch in the preceding twelve months. The margin was narrow, and but for the terrorist attack in June the two airports would have been equal. Glasgow improved in September, with 883,890 passengers, and was by far the busier of the two rivals, but cumulative totals kept Edinburgh ahead, where it remains. Passenger demand at Glasgow is greater throughout the Easter, October and summer school holidays of June to August. This seasonal variation, although apparent at most airports, is more pronounced at Glasgow due to the high number of charter flights, which makes predicting trends extremely difficult.

On 24 January 2008, Runway 09/27 was closed. It had been in operation since the 1960s, but handled just 257 traffic movements in 2006/07, and the £9-million savings made were used to pay for new seating, flooring and lighting in the terminal.

Glasgow is unique among international airports in that it shares the aerodrome with several other flying organisations – the Glasgow Flying Club and University Air Squadron with their light aircraft, and the Air Ambulance Service – but in March 2008, a new company moved in with unusual aircraft. Although Loch Lomond Seaplanes fly to some of the remotest areas in Scotland from the Science Centre on the River Clyde in Glasgow city centre, they use Abbotsinch as a maintenance base.

47

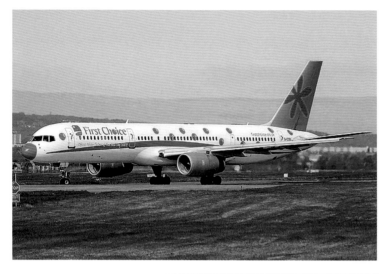

First Choice Airways
Boeing 757-2B7
G-OOBI, seen on
29 April 2007 in
a special livery
for Red Nose Day.
(Wallace Shackleton
Collection)

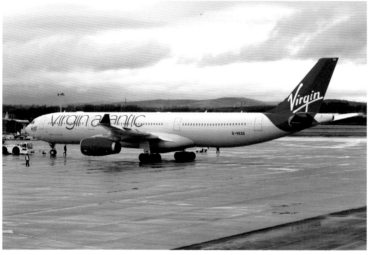

Virgin Atlantic
Airbus A330-343X
G-VKSS
*Mademoiselle
Rouge*. (Udo Haafke
Collection)

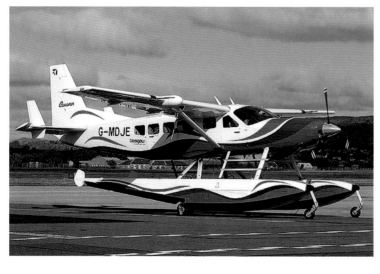

Loch Lomond
Seaplanes Cessna
208 Caravan I
G-MDJE. (Iain
Mackenzie
Collection)

Skyhub

On 3 December, Phase 1 of Skyhub was opened. Work started on the £30-million, 43,000 sq. ft two-storey building, situated between the main terminal and T2, in 2007, and was the biggest single investment in fifteen years. Built around a £3-million bombproof steel cage with eighty-eight pillars sunk 120 feet into the ground, the front is covered in Kalwall, a translucent material that has been used extensively at NASA's Cape Canaveral facility. Downstairs is a modern arrivals hall, but the first floor is the building's *raison d'être* – a football-pitch-sized, state-of-the-art security area with fourteen X-ray machines through which all departing passengers are screened. It replaces the separate security areas in the three piers, thus freeing up space for more shops, restaurants and a large duty-free area – all facilities that have become more important to both passengers and airport operators. Passengers now expect airports to offer the same range and standard of retail and leisure facilities found in the best shopping centres, and from the airport's perspective the income derived from these outlets is reinvested into the facilities, and helps to keep landing charges lower than those of some of its rivals.

The International Air Transport Association described 2009 as 'the worst year the industry has seen', with global demand down by 3.5 per cent. Passenger numbers plummeted by more than a fifth at Glasgow, prompting the airport to take the drastic action of closing T2 between the winter months of November 2009 and March 2010. The shutdown saved the airport £300,000, but proved to be an even greater bonus for easyJet, whose check-in desks were permanently moved from T2 into the main terminal. The collapse of Zoom and XL Airways during the downturn only exasperated the problems, but there was some good news in April when Emirates Airlines announced that their Glasgow–Dubai route had transported 1 million passengers in the five years it had been running.

With the scrapping of the Glasgow Airport Rail Link, the congested M8 is the only route available to get to Abbotsinch, and with this in mind, the airport contributed £1 million towards the M74 extension, a 5-mile route that bypasses Glasgow city centre, thus avoiding heavy congestion during peak hours, and reducing journey times to and from the hub.

If 2009 was the worst the industry had seen, then 2010 showed little improvement. Passenger numbers fell by a massive 9.6 per cent in March to 473,900, as a result of a strike at British Airways, poor weather and the collapse of Scottish airline Flyglobespan, but things went from bad to worse in May, following the eruption of the Eyjafjallajökull volcano in Iceland. The resultant disruption of air

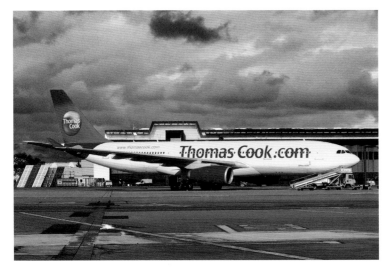

Thomas Cook
Airlines Airbus
A330-243 G-MDBD.
(Dr Bartolomeo
Gorgoglione
collection)

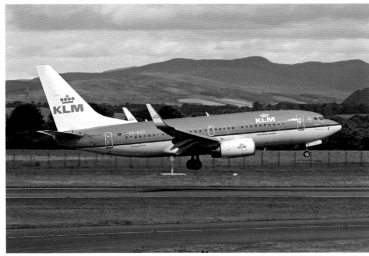

KLM Boeing 737-
7K2 PH-BGD. (Neil
Russell Collection)

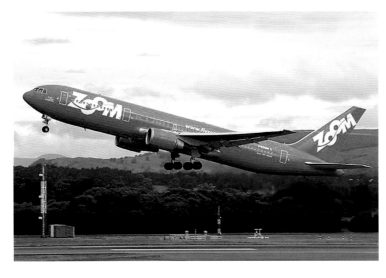

Zoom Airlines
Boeing 767-328-ER
G-GZUM. (Alistair
Bridges Collection)

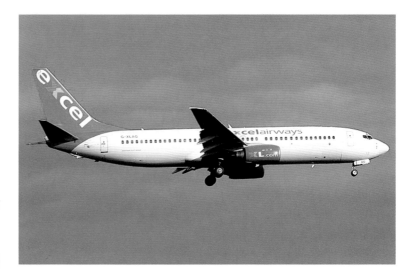

Excel Airways Boeing 737-86N G-XLAG landing out of a rain-filled sky. (Ian Robertson Collection)

traffic was the worst since the Second World War, and saw Icelandair temporarily use Glasgow as its base of operations. Despite the difficulties, the airport spent £2 million on a new passenger drop-off zone west of the terminal, replacing the temporary facility that had been introduced after the terrorist attack in 2007.

February 2011 saw the airport's snow-clearing fleet supplemented by the purchase of ten snow-clearing vehicles – tractors with brushes, de-icers and snow blowers – at a cost of £1.2 million. The month also saw the first rise in passenger numbers since August 2007; in fact, passenger numbers increased during every month of the year – a run not seen for six years.

On 22 February 2012, sixteen years after its first flight to Luton, the easyJet passenger count reached 20 million; another airline reaching a milestone was Jet2.com, which reached 250,000 passengers in its first year of operation.

In September, Glasgow became the first Scottish airport to enable passengers to scan their own boarding passes in the security area. The six scanners replace manual checks on boarding cards before travellers go through the security process. The emphasis on customer service also paid dividends in 2012, when Glasgow won Scottish Airport of the Year. Other accolades included recognition from Renfrewshire Chamber of Commerce; Scottish Transport; Occupational Health and Safety Awards; Excellence in Customer Service, Glasgow Business Awards; Healthy Working Lives Gold Award; an International Safety Award; and a Gold award from the Royal Society for the Prevention of Accidents. The airport was also the first in the UK to launch a Customer Charter, which sees staff members being trained to put themselves in the place of passengers, and to be efficient, friendly and helpful.

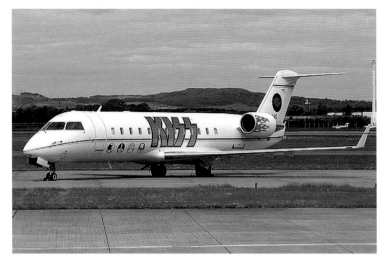

Canadair Regional Jet CRJ-200ER PH-AAG, used by the rock band KISS on their 2010 'Sonic Boom' world tour. She is now owned by MNG Jets and registered as TC-EJA. (Iain Mackenzie Collection)

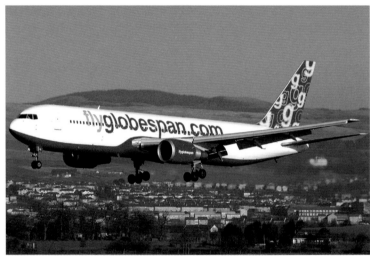

Flyglobespan Boeing 767-319-ER G-CEFG. After the company ceased trading, she was re-registered by Omni Air International as N396AX. (Alistair Bridges Collection)

Boeing 757-208WL TF-FII first flew in April 1990, and was delivered to Icelandair the following month. Since then, however, she has led a very nomadic existence, being leased to BMI, Air Méditerranée, Air Niugini and SBA Airlines. Initially named *Fanndis*, her name was changed in 2010 to *Eyjafjallajökull* in honour of the infamous Icelandic volcano that caused so much disruption to air travel in May 2010. (Udo Haafke Collection)

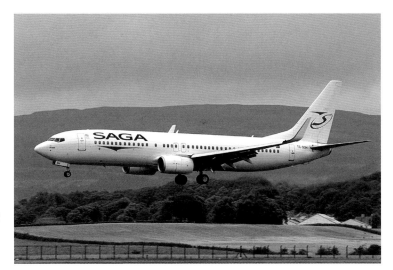

Saga Airlines Boeing
737-86J TC-SGH.
(Neil Russell
Collection)

British Airways
Citiflyer Embraer
170-100STD G-LCYD.
(Neil Russell
Collection)

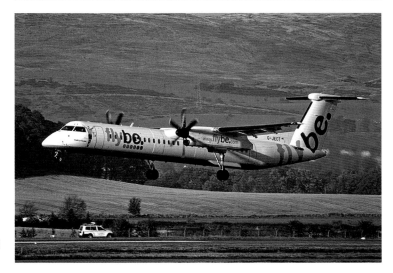

Flybe Bombardier
Dash 8-Q402
G-JECT. (Neil Russell
Collection)

FlyDubai's new fleet of Boeing 737s passed through Abbotsinch on their delivery flights from the factory. (Iain Mackenzie Collection)

From 1 January 2013, Emirates Airlines, an official partner of the Glasgow 2014 Commonwealth Games and the Official 'Queen's Baton Relay' Airline, announced an upgrade to its second daily Dubai flight. Boeing 777-300ER aircraft replaced Airbus A340-300s, giving an increase of 650 seats and 77 tons of cargo each week.

On 26 February the airport announced a £10-million upgrade for the 2014 Commonwealth Games; the main terminal was to receive new seating and flooring, while a new heating and ventilation system would be installed in T2. £1.5 million of the total was allocated to upgrading the toilets within both terminals! On the airfield, LED lighting was to be installed on the taxiways.

From April, Boeing 747s replaced Airbus A330s on Virgin Atlantic's Orlando route, thus increasing capacity during the summer holidays – the Florida flights carried 40,000 passengers in 2012. The summer also saw two more 'firsts' for the airport. In June, Glasgow became the first UK airport to achieve five stars in a safety audit by the British Safety Council, and on 8 July it became the first in Scotland to operate the Boeing 787 Dreamliner, when Thomson Airways, the UK's third-largest airline, flew its inaugural service to Cancún. United Airlines passengers were greeted by an Elvis impersonator and showgirls for their flight on 16 July; the occasion was the fifteen anniversary of the airline's Glasgow–Newark service. November was also the busiest in six years, the tenth consecutive month of passenger growth, and 2013 proved to be the busiest since 2008, with 7.4 million passengers passing through the gates.

November 2013 saw Gama Aviation open a 17,222 sq. ft maintenance hangar and executive aircraft operations centre, in the first phase of a £17-million program. The facility, midway between its bases in Sharjah and Texas, accommodates its own Beechcraft King Air 350C G-GMAD, and Scottish Air Ambulance Beechcraft King Air 200 G-SASC.

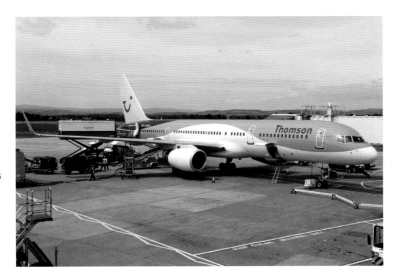

Boeing 757-204 G-BYAY first flew with Britannia Airlines, but moved to Thomson Airways in May 2005, and is seen here being prepared for her next flight on a very busy apron. (Udo Haafke Collection)

Emirates Airlines Boeing 777-31H A6-EMX. The Emirates logo emblazoned on her belly is 40 feet long, and the initial letter, E, stands 7 feet tall. (Mohammad Farhadi Collection)

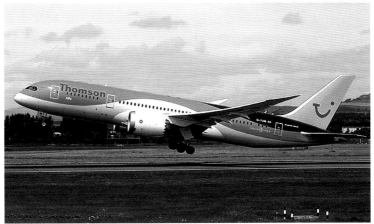

Thomson Airlines Boeing 787-8 Dreamliner G-TUIB. The £150-million aircraft can carry up to 291 passengers at 41,000 feet and 540 mph, and is specially designed for long-haul flights. It uses less fuel and creates less noise than other aircraft of its size and capability. (Iain Mackenzie Collection)

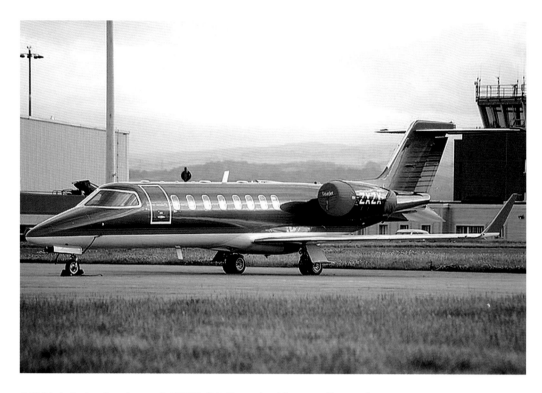

GAMA Aviation Learjet 45 G-ZXZX. (Wallace Shackleton Collection)

Also in November, the Scottish Government purchased Prestwick airport for the princely sum of £1, thereby returning it to public ownership. At present, Glasgow airport shares commercially confidential information about its strategic intentions with Government officials, but those same officials are now also looking to increase Prestwick's role, and as the two airports directly compete for passengers, it could potentially create a conflict of interest. However, until the Scottish Government declares its intentions for Prestwick, the situation remains unclear.

A positive start to 2014 saw Glasgow become the first UK airport to receive the Airport Council International's Airport Service Quality (ASQ) Assured Certification for service and quality, and in excess of 436,000 passengers were logged in February, a year on year increase of 6 per cent.

Ferrovial, the Spanish firm who took control of BAA in June 2006, announced in February that it was looking to expand its UK portfolio by purchasing Aberdeen, Glasgow and Southampton airports, and in an extraordinary twist, Glasgow City Council's pension fund, known as the Strathclyde Pension Fund, also expressed an interest. It was Glasgow Corporation, forerunner to the City Council, who owned the airport until 1975. Ferrovial completed the deal in October 2014.

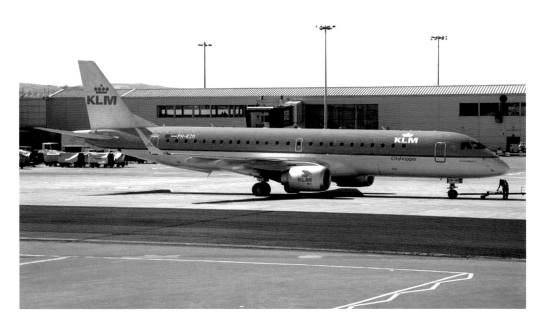

KLM Cityhopper Embraer ERJ-190STD PH-EZO. (Udo Haafke Collection)

When the Edinburgh tram system opened in May 2014, Glasgow became the only Central Belt Scottish airport without a rail link, but in August 2014 the UK Government, along with the Scottish Government and eight local authorities, announced the £1.13 billion Glasgow and Clyde Valley City Deal. Under this agreement, the rail link was reinstated.

The airport has also had a very busy year, as during 2014 Scotland played host to the Commonwealth Games; the Ryder Cup; the UK leg of the IAAF Diamond League Athletics competition and the MTV Music Awards.

And so, as Glasgow International Airport approaches its fiftieth anniversary, it is clear that it will not only increasingly contribute to the development of Scotland and the UK, it will also play a prominent role in the global market.

The Future

The popularity and convenience of air travel will inevitably mean an increase in airport capacities around the world, and furore like that over the third runway at Heathrow will become more frequent.

While its location is constrained by physical barriers – a motorway, two rivers and the town of Renfrew – and the current lack of a direct rail link, Glasgow airport has drawn up plans for expected growth up to 2040. If it comes to fruition, it will see minimal impact on the environment while catering for an anticipated 20 million passengers per annum.

Airport Development to 2020

It is predicted that Glasgow airport could be handling up to 10 million passengers a year by 2020. However, with just a few alterations, the terminal will accommodate this growth within its existing footprint. The piers and stands would need to be reconfigured to provide thirty-nine 'jumbo' stands, but Runway 05/23 has the capacity to handle the increased traffic without any modifications, and in fact, the only additional capacity required would be extra car parking spaces.

Airport Development to 2040

Beyond 2020 trends are more difficult to anticipate, but the forecast is that the airport will handle up to 20 million passengers a year by 2040.

If passenger numbers reach 16 million, then the terminal will need to be extended, a second international pier added, and the East pier replaced, to provide up to fifty aircraft stands. Runway 05/23 is not expected to reach capacity until near 2040, but to handle further traffic it would require the purchase of 128 acres of land between the current boundary and White Cart Water, in order to realign Taxiway Alpha.

If passenger numbers rise to 20 million, then consideration would be given to a second 6,000-foot-long runway, north of and parallel to 05/23, which would also require the purchase of the 128 acres of land and the relocation of the cargo area and two public roads.

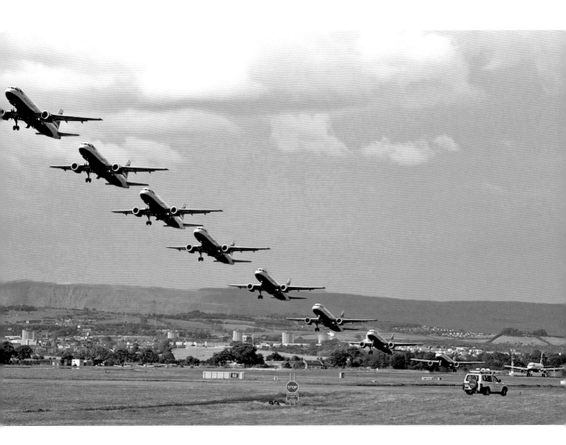

Despite increasing traffic, Abbotsinch will never be quite as busy as this remarkable record of a British Airways Airbus A319 departure from Runway 23. (Wallace Shackleton Collection)

To mitigate homeowners from the risk of blight if a second runway is built, the airport launched two schemes in 2005. The Property Market Support Bond guarantees that the airport will buy affected properties at an un-blighted market rate, if the airport applied for planning permission, while the Home Owner Support Scheme protects the value of properties affected by high levels of noise, and again guarantees that the airport will purchase at an un-blighted market price once planning permission has been obtained for the new runway.

Freight Operations

KLM DC9-32 PH-DNO introduced the first regular cargo service from Abbotsinch on 2 September 1968, with a five-times-weekly flight to Amsterdam via Manchester. Up to then most cargo was either loaded in passenger aircraft or sent by road to Manchester.

By 1992, the airport's original cargo facilities were over twenty years old and were struggling to cope with the increasing volumes, so in December 1993 a £2-million programme was initiated. Called the 'Cargo Village', when completed in 1999 it consisted of two warehouses of 42,000 sq. ft and 200,000 sq. ft.

In November 2011, the Airport Industrial Property Unit Trust launched 'The Hub', a 43,000 sq. ft warehousing unit, at its Air Cargo Centre next to the airport.

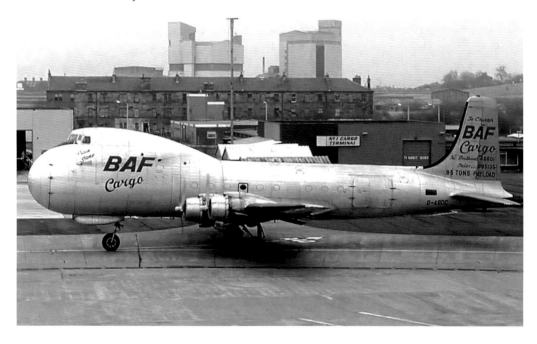

British Air Ferries ATL-98A Carvair G-ASDC *Plain Jane*. This was one of twenty-three Douglas DC-4s converted to freighter configuration, with an enlarged nose housing a clam-type door, and used as vehicle ferries. (Paul Thallon Collection)

Originally registered as G-BGNK with Fairflight Charters, this Embraer EMB-110-P2 Bandeirante flew with African International Airways before being purchased by Air Ecosse and re-registered as G-DATA (as seen here). Sold in April 1990, she now flies in Australia as VH-OZF. (Paul Thallon Collection)

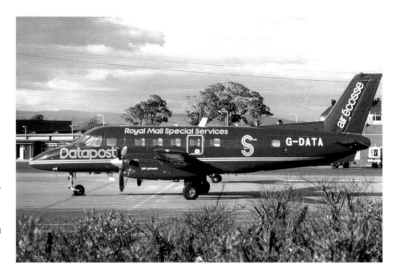

Instone Airlines Bristol 170 Freighter 31E G-AMLK was used to carry racehorses until 1984, and was briefly re-registered in Canada as C-GYQS with Trans-Provincial Airlines. She was retired in 2000 but is no longer airworthy. (Alistair Bridges Collection)

Airbridge Vickers Merchantman 953C G-APEP *Superb*. A conversion of the Vanguard airliner, this particular aircraft was a frequent visitor to Abbotsinch and is now preserved at Brooklands Museum, Weybridge, the sole surviving example of the forty-four built. (Alistair Bridges Collection)

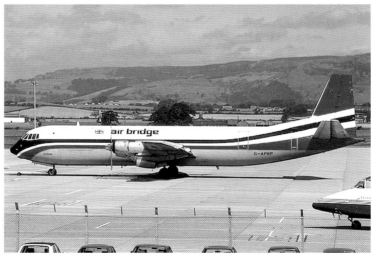

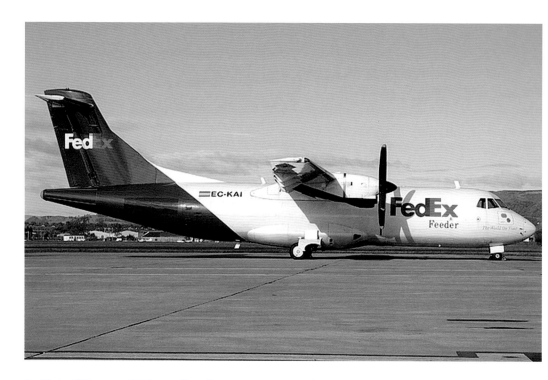

Swiftair ATR-42-300F EC-KAI first flew as N431MQ with American Eagle, and has also passed through the hands of Federal Express and Air Contractors. Since 2007 she has been owned by Swiftair, and is seen here in FedEx livery. (Iain Mackenzie Collection)

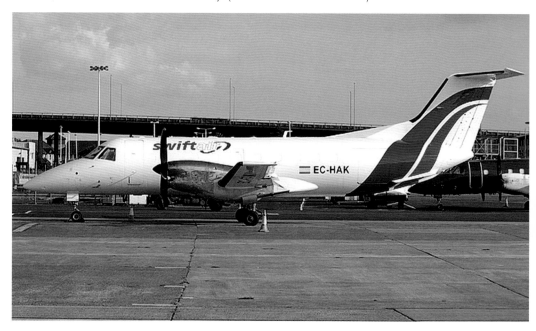

Embraer EMB-120T(F) Brasilia EC-HAK of Swiftair Cargo was initially delivered to Atlantic Southeast Airlines as N212AS, and was purchased by Swiftair in 1999, subsequently being converted to freighter configuration. (Iain Mackenzie Collection)

The Rescue Services

The Air Ambulance

Due to the unique geography, the air ambulance service is an essential component of healthcare provision in Scotland, especially for residents of the many west coast islands, and is the only Government-funded air ambulance service in the UK. Its specially equipped and distinctively painted yellow aircraft can trace their origins back to 1933, and together with their highly trained medical and flight crews, provide round-the-clock cover for routine and urgent patient transfer.

BEA operated ad hoc ambulance flights from February 1947, before setting up a dedicated Air Ambulance Unit in April 1948 under Captain David Barclay. From 12 February 1955 it flew de Havilland Herons at an annual cost of £12,000. The service was originally flown from Renfrew, but when it was closed BEA moved to Abbotsinch and continued until the Herons were retired in 1973, when the responsibilities of the Scottish Air Ambulance Service were handed to Loganair. They continued until 2005, when GAMA Aviation won the tender to provide the air ambulance services and operate two Eurocopter EC-135 helicopters (based at Glasgow City Heliport and Inverness airport under subcontract by Bond Air Services) and two Beechcraft SuperKing Air Be200Cs, one at Aberdeen airport and the other – G-SASC – housed in GAMA's purpose-built hangar at Glasgow airport. In 2010/11, the air ambulance fleet flew 3,774 missions.

Fire and Rescue

The airport fire station, located near what used to be the intersection of the two runways, was originally built in 1966, but was extended in 1985 at a cost of £500,000. The architects were none other than Sir Basil Spence, Glover & Ferguson. Its location allows the fire appliances to reach any part of the aerodrome within three minutes. Its six bays house three major foam tenders, two light foam tenders and one command vehicle, and there are seventy-two operational firefighters operating four twelve-hour watches providing round-the-clock coverage.

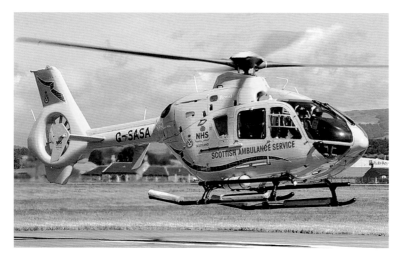

Eurocopter EC-135T-1 G-SASA. Operated under subcontract to GAMA by Bond Air Services, she is based at the Glasgow heliport on the banks of the Clyde, but is maintained at GAMA's facilities at Abbotsinch. (Iain Mackenzie Collection)

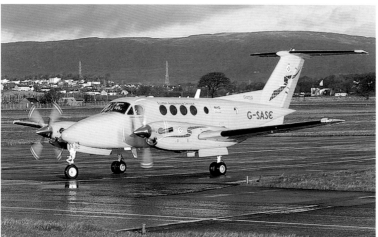

Beech 200C King Air G-SASC is named in honour of paramedic John McCreanor, who was lost, along with his pilot, when their Loganair ambulance – G-BOMG – crashed into the sea off Campbeltown on 14 March 2005. (Iain Mackenzie Collection)

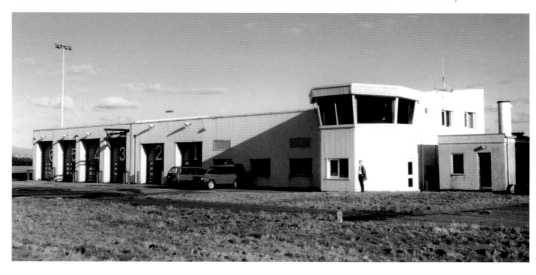

Glasgow airport fire station. (Graeme Kirkwood Collection)

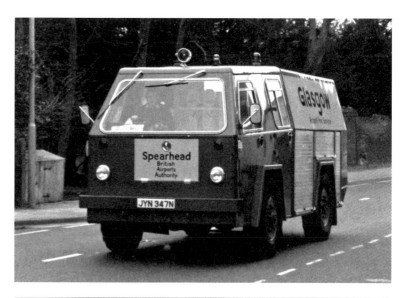

A 1974 photograph of the Chubb Spearhead Rapid Intervention Vehicle, JYN 347N. Fifteen were purchased by BAA, and were equipped with a Godiva two-stage fire pump, a 200-gallon fibreglass water tank, 15-gallon light water concentrate tank, two hand lines and a high-pressure first aid hose reel. She was capable of 65 mph and carried a crew of four.

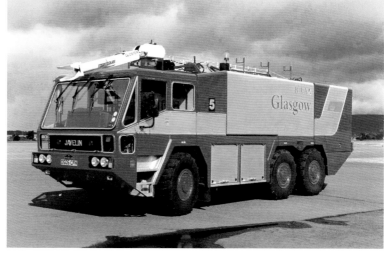

A 1994 photograph of Gloster Saro Javelin Mk.2 D505CFH. (Graeme Kirkwood Collection)

Six appliances are at immediate availability in the station, and are kept at a constant temperature with their batteries on charge at all times, which ensures immediate start-up whatever the weather conditions.

FIRE 1 Mitsubishi Shogun Command and Control
FIRE 2 Rosenbauer CA5 Panther 6x6 MFT
FIRE 3 Rosenbauer CA5 Panther 6x6 MFT
FIRE 4 Rosenbauer CA5 Panther 6x6 MFT
FIRE 5 Scania 124C-420/Carmichael Viper Light Foam Tender
FIRE 7 Carmichael Cobra 2 MFT
Spare Scania 124C-420/Carmichael Viper LFT
Spare Mitsubishi Shogun Command and Control
Spare Carmichael Cobra 2 Major Foam Tender

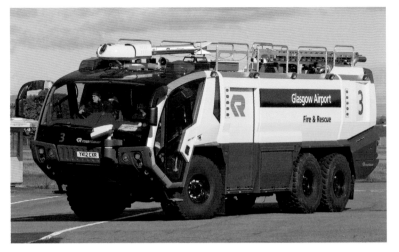

A 2014 photograph of Rosenbauer CA5 Panther Major Foam Tender #3 YL12 CXR. The flagships of the fleet are three of these £600,000 vehicles, which film fans will recognise as Sentinel Prime from the third Transformers film, *Dark of the Moon*. The 33-ton Austrian-built appliance is at the cutting edge of firefighting technology, and carries 2,900 gallons of water and 3,500 gallons of foam, yet can still accelerate from 0 to 50 mph in thirty-two seconds. The water cannon on the roof can reach almost 80 yards at 11 bar pressure, and is operated via a joystick from the cab. (Graeme Kirkwood Collection)

CAA legislation states that there must be a minimum of 2,600 gallons of water and 160 gallons of foam liquid available at all times – the airport meets this requirement by having a rapid replenishment system and high-pressure hydrants along the length of the runway, which are fed from a 50,000-gallon water tank pumped by four diesel engines that are activated when a hydrant is opened.

Over the years three aircraft have been used by the fire service for non-destructive training purposes. First was Douglas DC-3 G-ALYF, which arrived on 19 March 1968. Ex-Royal Air Force Vickers Varsity WJ903 'C' came from No. 6 Flying Training School on 6 February 1975 and was used until August 1983 when, minus her rudder and windows, she was moved to the Dumfries & Galloway Aviation Museum. The final aircraft was British Airways Trident 1c G-ARPP. She flew her last flight from Heathrow, and after her passengers disembarked she was retired and moved to the fire dump. During 1996 she was painted in BAA livery and used for air bridge training on the new international pier, then for smoke evacuation training by airline staff, but after twenty years' service she was broken up for scrap in May 2003. The fire training ground, in the north-west corner of the aerodrome, houses a simulated aircraft fuselage with a pressurised fuel supply along its upper surface that, when activated, produces a 'wall of fire' on each side of the structure.

Because the River Cart flows past the end of the runway, the airport also has two Zodiac rescue dinghies. As with the fire appliances, they are checked daily and there are frequent training exercises.

Vickers Varsity T.1 WJ903 arrived from No. 6 Flying Training School on 6 February 1975 for fire training. Looking rather the worse for wear, she is seen here in March 1976, when she was parked behind the fire station, and was moved to the Dumfries & Galloway Aviation Museum for preservation in August 1983. (Bob Woolnough Collection)

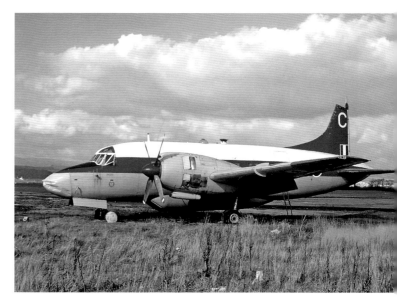

Hawker Siddeley Trident 1C G-ARPP. During 1996 this ex-British Airways aircraft was painted in BAA livery and used for Airbridge training on the new international pier. She is seen here on 28 November 2002, parked in Area R near the western perimeter, but was broken up for scrap in May 1983; the nose section is preserved at the Dumfries & Galloway Aviation Museum. (Jan Mogren Collection)

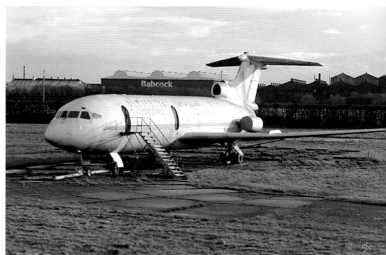

Simulated aircraft fuselage. (Author)

The Tower

Located between the main runway and apron area, the 50-foot-high air traffic control tower provides clear and uninterrupted views across the aerodrome. Originally built in the late 1940s, it was upgraded in the 1960s and again in 1985, but remains substantially unchanged, making it unique in the UK. Looks can be deceptive, however, as it houses state-of-the-art air traffic control systems, surface movement radar and primary surveillance radar.

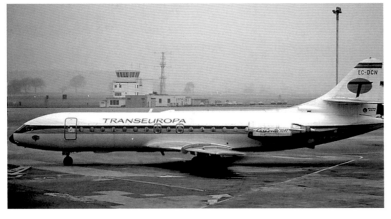

After Concorde, the Sud Caravelle was possibly the most graceful airliner ever built. This SE-210 Caravelle 10B1R was originally delivered to Alia in 1965, and also flew with Air Afrique, Hispania and EAS before moving to Transeuropa as EC-DCN. (Ian Robertson Collection)

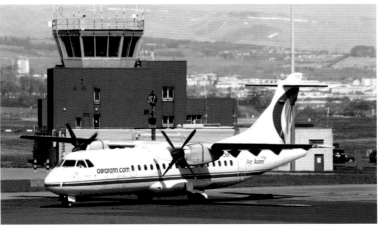

Aer Arran ATR 42-300 EI-CBK *St Fionntain* on Stand 82. (Udo Haafke Collection)

The backup tower is situated on the northern side of Runway 05/23, and is ready to go at a moment's notice. (Author)

You expect roadworks en route to the airport, but not on the way to take-off! This was the scene during the construction of the international pier. (Bill Crookston collection)

Due to the close proximity of the Campsie Hills, in 2012 Glasgow was the first airport in the UK to benefit from a new safety enhancement developed by the National Air Traffic Services (NATS). Using satellite data, a three-dimensional map of the terrain around the airport was integrated with standard NATS systems; it triggers a warning when aircraft are either descending too quickly or are in close proximity to the ground.

Passenger safety is not only confined to the boundaries of the airport. The Aerodrome Safeguarding and Public Safety Planning Team liaise with local planning authorities to identify planning applications on which the airport must be consulted; these involve tall buildings and structures, such as telecommunications masts and wind turbines. The latter are the biggest concern to air traffic control due to their height and visibility to radar. A poorly located wind farm can reduce airspace, resulting in additional fuel burn as aircraft are forced to fly on longer routes to avoid them.

In December 2005, for example, the airport withdrew its two-year objection to a Scottish Power plan for one of the largest wind farms in the world, the 21 square mile, £150-million development consisting of 140 turbines at Whitelee on Eaglesham Moor south-east of Glasgow. It now provides power for 200,000 homes, half of the city's requirements, but the original plans would have resulted in the turbines appearing on the air traffic control radar. In conjunction with NATS, however, an additional radar, costing £5 million, was built at Kincardine, Fife, and tracks aircraft directly above the farm. It then feeds the data to the control tower at the airport, where it integrates with the radar data there to give the controllers a complete picture.

Other Airport Users

Loganair

Loganair Limited is an independent, privately owned airline based at Glasgow airport, and is known as Scotland's Airline. From its modest beginnings in 1962 as the air taxi service of the Logan Construction Company, it has developed into a regional commuter airline with a comprehensive network of scheduled services, and is one of the longest-established airlines in the United Kingdom. It primarily operates routes within the Highlands and Islands of Scotland, employing a fleet of turboprop aircraft.

Between 1968 and 1983, the airline rapidly expanded when British Airways transferred some of its less utilised routes to Loganair; then in September 1983, the British Midland Group took a controlling interest in the company. In addition to the Scottish routes, it also commenced operations from Manchester, Southampton and Belfast, but a reorganisation of the group in 1994 saw the transfer to Manx Airlines (Europe) of services south of the border and their associated aircraft. A management buyout secured the remaining (Scottish) routes, and a franchise with British Airways ensured the company's survival. With one de Havilland Twin Otter and five Britten Norman Islanders wearing British Airways livery, the company dedicated itself to the provision of air services to Orkney, Shetland and the west coast of Scotland.

After a fourteen-year franchise with British Airways, Loganair forged a new partnership with Europe's largest regional carrier, Flybe, in July 2008. Again, the airline's aircraft fly in the livery of its partner, but Loganair remains responsible for all operational and commercial decisions relating to the network. The association with British Airways continues, however, with Loganair flights marketed as connecting with BA flights to London and beyond.

March 2004 saw a transfer of routes and aircraft from British Airways CitiExpress, including the Glasgow–Benbecula, Stornoway, Shetland and Isle of Man routes, as well as Shetland–Aberdeen, while the acquisition of charter specialist Suckling Airways of Cambridge added six Dornier 328 aircraft to its expanding fleet.

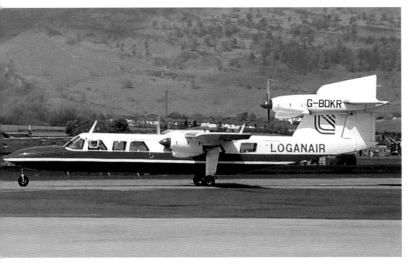

Britten-Norman BN-2A-III-2 Trislander G-BDKR flew with Loganair between March 1976 and May 1982. The company's two Islanders had a crew of one and carried eight passengers on the inter-island services from Kirkwall to the six north isles of Orkney. (Paul Thallon Collection)

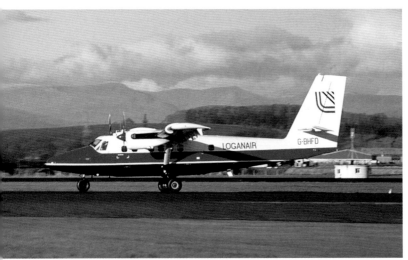

De Havilland Canada DHC-6-300 Twin Otter G-BHFD had the longest delivery flight of any of the Twin Otter fleet. Collected from Fields Aviation in Calgary, Canada, she flew via Greenland and Iceland to Glasgow, a flight time of eighteen hours. (Paul Thallon Collection)

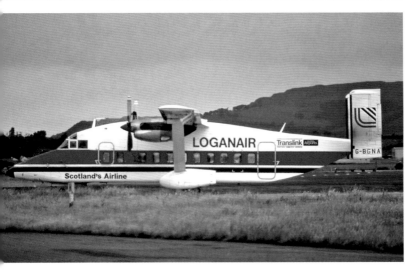

Shorts SD3-30 100 G-BGNA burst a tyre landing at Stornoway on 9 February 1998 but escaped major damage. (Paul Thallon Collection)

Fokker Friendship F.27-100 G-IOMA was leased by Loganair from British Midland between November 1983 and May 1986. (Paul Thallon Collection)

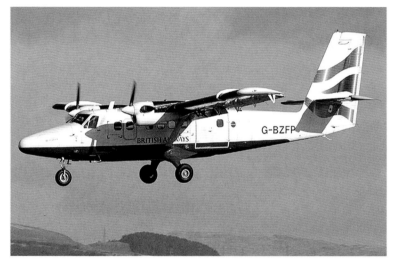

De Havilland Canada DHC-6-300 Twin Otter G-BZFP. (Iain Mackenzie Collection)

In 2012, Loganair celebrated its fiftieth anniversary, and currently the airline operates approximately 120 flights each day, carrying 486,000 passengers per year on a network of thirty-one scheduled service routes. The routes to the Scottish Islands are considered to be a lifeline by their residents: in addition to a franchise with Royal Mail, the airline also carries daily newspapers and other items essential for the maintenance of island life, including, among other things, medical supplies, blood samples and bank consignments. It also carries consumer goods to, and exports of produce from, the Islands.

The airline's network contains a number of unique operations, including Europe's only scheduled services to and from a beach landing strip, Traigh Mhòr on the island of Barra, where flight times are subject to the tides. The two-minute flight between Westray and Papa Westray, operated as part of the Orkney inter-isles network, is the world's shortest

scheduled air service, covering a distance less than the main runway at Glasgow between take-off and touchdown. Scheduled flight time is two minutes, but it has been completed in as little as fifty-eight seconds.

Line maintenance is conducted at Glasgow, Edinburgh, Aberdeen, Dundee, Inverness, Kirkwall and Sumburgh, but major maintenance on the Saab 340 and Twin Otter aircraft is undertaken in the company's own hangar facilities at Abbotsinch, where the airline provides contracted engineering support to a number of other airlines, including Emirates, Air France, BA City Flyer and Swift Air.

The company also offers ground handling capability at eight airports in the Highlands and Islands, and its wholly owned subsidiary Aero Handling provides full ground handling, including de-icing capability, at Aberdeen and Sumburgh in the Shetland Islands to a number of customers, including West Atlantic, Bristow Helicopters, CHC Helicopters, easyJet and BenAir.

So the company that started as a taxi service with one Piper Aztec goes from strength to strength. The current fleet consists of twenty-six aircraft – two de Havilland Canada DHC-6 Twin Otters; fourteen Saab 340Bs; two Saab 340A freighters; two Britten-Norman Islander 2s and six Dornier 328-100s. Three Saab 200s will be added to the line-up in 2014.

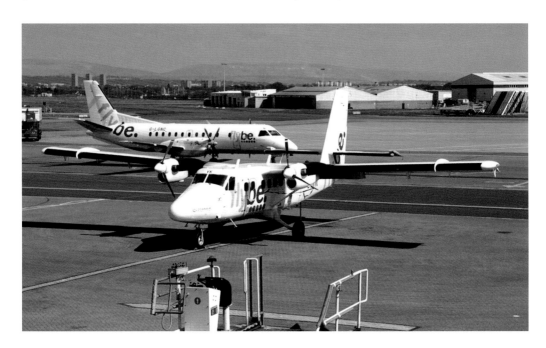

De Havilland Canada DHC-6-300 Twin Otter G-BVVK in Flybe livery. Loganair's two Twin Otters have a crew of two, can carry eighteen passengers and are used on the Barra, Tiree, Campbeltown and Benbecula routes. (Ian Robertson Collection)

De Havilland Canada DHC-6-300 Twin Otter G-BVVK. (Udo Haafke Collection)

Loganair operate fourteen Saab 340Bs. G-LGNG, like her sisters, has a crew of three, two pilots and a cabin crew, and can carry thirty four passengers. (Dr Bartolomeo Gorgoglione Collection)

University Air Squadron

The RAF still maintain a presence at Abbotsinch, in the guise of the universities of Glasgow and Strathclyde air squadrons, unique among university air squadrons in that they are based at a busy international airport rather than an RAF station.

It arrived on 8 November 1968 with five de Havilland Chipmunks, which were exchanged in March 1974 for Prestwick-built Scottish Aviation Bulldog T1s. These in turn were replaced in March 2000 by two Grob Tutor T.1 two-seat, fully aerobatic, single-engine piston trainers. A reorganisation in January 2008 saw two flights created – Clydesdale and MacIntyre – named in honour of Lord Clydesdale and David McIntyre (see the section on No. 602 Squadron).

Grob G-115E Tutor T.1 G-BYUD. Built in 1999 by Grob Aerospace in Germany, she is one of 117 owned and operated by Babcock and contracted to the Ministry of Defence. They carry RAF roundels as well as civilian registration marks. (Iain Mackenzie Collection)

Grob G-115E Tutor T.1 G-CGKN. Built from carbon composite materials, the wings and fuselage are one piece. She carries No. 602 Squadron markings in front of the registration mark. (Iain Mackenzie Collection)

Under a Private Finance Initiative, the aircraft are owned and operated by Babcock, and contracted to the Ministry of Defence. They are painted overall white with blue flashes and UK military aircraft roundels, though they also carry British civilian registration marks.

Glasgow Flying Club

Glasgow Flying Club formed at Renfrew in 1963, and is one of oldest in the UK. Initially one of three flying clubs based at the aerodrome, the others being the West of Scotland and the Renfrew flying clubs, its clubhouse is situated on the north side of the airfield, with a dedicated ramp that has tie-downs for six aircraft and a parking area for visitors.

Unusual in that it is based on an international airport, student pilots get the unique experience of sharing the same runway with large passenger jets and flying within international air traffic control zones.

The club currently has three aircraft – Cessna 172S Skyhawk SP G-IZZS, Piper PA-28-161 Cherokee Warrior II G-SRWN and Piper PA-38-112 Tomahawk G-BSOU.

Cessna 172SP
Skyhawk G-IZZS.
(Author)

Piper PA-28-161
Warrior II G-SRWN.
(Author)

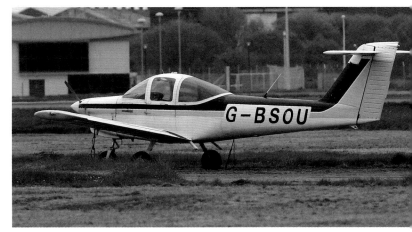

Piper PA-38-112
Tomahawk G-BSOU.
(Author)

Other Visitors

The airport has two helipads, and many helicopters can be seen on the general aviation apron to the east of the terminal.

 With many large corporate headquarters based in the city of Glasgow, there is a constantly changing array of executive aircraft parked on the apron.

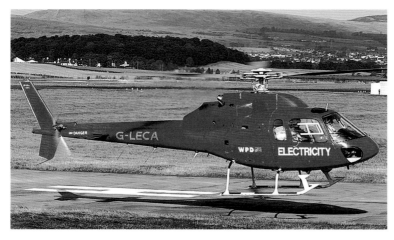

Aerospatiale AS-355F-1 Ecureuil 2 G-LECA is owned by South Western Electricity Board and operated by its Western Power Distribution division. (Iain Mackenzie Collection)

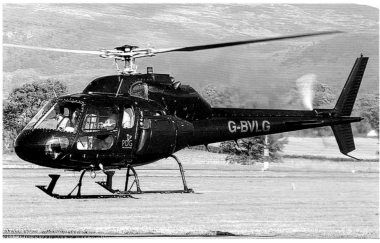

Aerospatiale AS-355F-1 Ecureuil 2 G-BVLG of PDG Helicopters starred in the movie *Sweet Liberty* with Alan Alda and Michelle Pfeiffer. (Iain Mackenzie Collection)

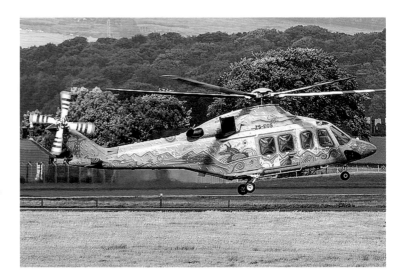

South African registered Augusta-Bell AB-139 ZS-EOS is operated by Fireblade Investments. (Iain Mackenzie Collection)

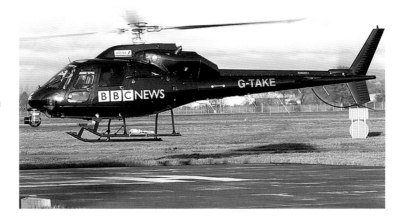

BBC News Aerospatiale AS-355F-1 Ecureuil 2 G-TAKE was based at Abbotsinch while covering the police helicopter crash in Glasgow city centre in early December 2013. (Iain Mackenzie Collection)

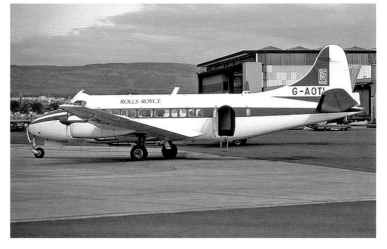

Rolls-Royce de Havilland Heron 2D G-AOTI is now on permanent display at the de Havilland Museum in Hertfordshire. (Paul Thallon Collection)

Tenneco Aviation Hawker Siddeley HS.125-600B G-BETV. (Paul Thallon Collection)

Bombardier Learjet 36 N14CF. (Neil Russell Collection)

Cessna 525A Citation CJ2 G-OODM. (Iain Mackenzie Collection)

Socata TBM-850 N562CC. (Neil Russell Collection)

With the snow-covered Campsies as a backdrop, Cessna 525A Citation CJ2 G-CGSB is seen en route to the Caribbean. (Iain Mackenzie Collection)

Solid Air Piaggio P-180 Avanti II PH-HRK. (Iain Mackenzie Collection)

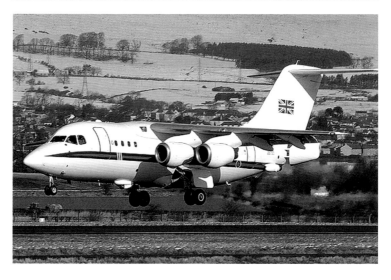

British Aerospace BAe-146-100 Statesman ZE700 of the Queen's Flight. (Iain Mackenzie Collection)

The airport has benefited greatly from the success of Glasgow's two main football teams in European cup competitions. Between 1966 and 2011 Rangers and/or Celtic qualified for European competitions in every season but two, with fans departing for the away games from the airport. Both clubs chose Abbotsinch as the venue for their first shops in 2004. Other football matches and sporting events have also boosted passenger numbers over the years.

In May 1967 Jock Stein and his Celtic team flew to Lisbon for the European Cup Final in Dan Air Comet G-APDO; they returned with the Cup, having beaten Internazionale 2-1, and went down in history as the 'Lisbon Lions'.

The 12 May 1976 European Cup Final at Hampden between Bayern Munich and Saint-Étienne saw no fewer than twelve Caravelles; seven DC-8s; four Vanguards; three Boeing 727s; three Boeing 747s; two BAC 1-11s; a A300; a Boeing 707; a DC-9; a Herald; a Trident; a VFW-614; and twenty-seven executive jets arrive on the day.

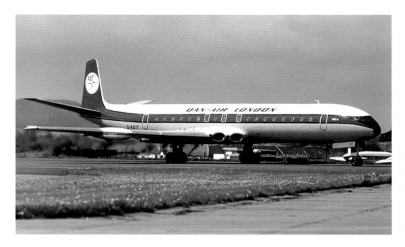

Dan-Air de Havilland Comet 4C G-BDIT, sister aircraft of the Comet that flew the Celtic team to the 1967 European Cup Final. (Paul Thallon Collection)

Intra Airways C-47B Dakota G-AMPY was a football charter for the 1976 European Cup Final. (Paul Thallon Collection)

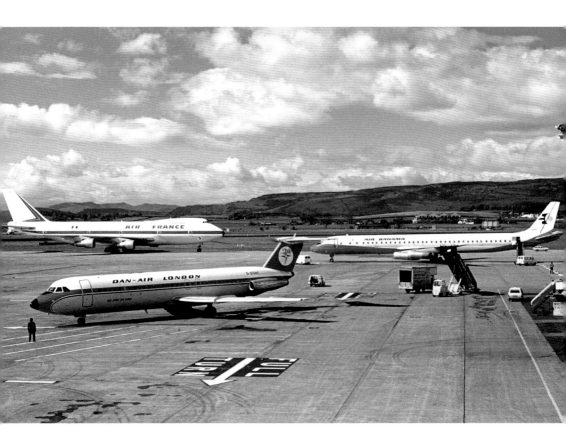

On 12 May 1976, Air France Boeing 747-128 F-BPVF taxies in with a cabin full of Saint-Étienne football fans for the European Cup Final at Hampden. Also visible are Dan-Air BAC 111 G-BDAT and Air Bahamas DC8-630CF N8630. (Bill Crookston Collection)

The 2002 UEFA Champions League Final between Real Madrid and Bayern Leverkusen at Hampden Park saw over one hundred aircraft arrive on the day. Real Madrid won the game 2-1, Zinedine Zidane scoring the winner with a left-footed volley from the edge of the box, which has since been voted one of the greatest ever goals.

When the draw for the 2007 UEFA Cup quarter-finals took place in Glasgow, the actual trophy was put on display at the airport. The final, played at Hampden on 16 May, saw Seville beat Espanyol 3-1 on penalties after the match was drawn 2-2. An estimated 30,000 fans passed through the airport to watch the game.

The British Open, held at Royal Troon in July 2004, helped Glasgow to become the first Scottish airport to handle 1 million passengers in a month (1,007,400).

In 2014, the World Cup passed through the airport on its whistle-stop worldwide tour.

Many military flights are just passing through Abbotsinch en route to elsewhere, but quite a few are visitors to the University Air Squadron.

USAF Lockheed C-141A Starlifter 64-0647. (Paul Thallon Collection)

CASA C-212-300 Aviocar FAP250 arriving in a snowstorm during a delivery flight to the Fuerza Aerea Panamena (Panama Air Force) in February 1998. (Neil Russell Collection)

Westland SA-341B Gazelle AH.1 XZ334. (Iain Mackenzie Collection)

British Aerospace Hawk T.1 XX325 in the '90th Anniversary of the RAF' display colours on 24 May 2008. She is now one of the Red Arrows display aircraft. (Iain Mackenzie Collection)

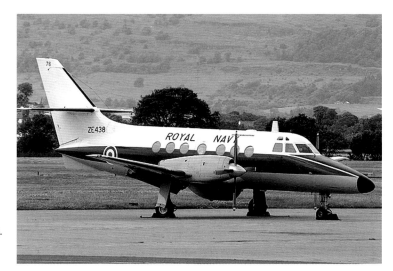

Royal Navy BAe-3100 Jetstream T.3 ZE438. One of four T.3s owned by the Navy, they are used for observer training. (Iain Mackenzie Collection)

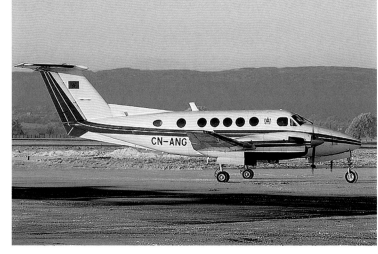

Moroccan Air Force Beechcraft 200 Super King Air CN-ANG is seen in the late afternoon sun on return from the USA, where she was converted to a cloud-seeding aircraft. (Iain Mackenzie Collection)

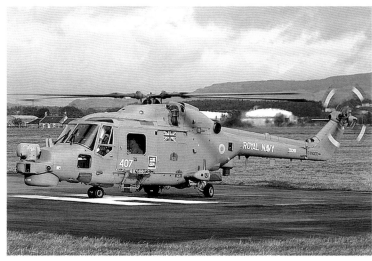

Westland Lynx HAS.3 ZD261. A former member of the Black Cats helicopter display team, she is now based on the Royal Fleet Auxiliary *Largs Bay*. (Iain Mackenzie Collection)

KLM DC-3 – Wednesday 17 April 2011

Tuesday 21 May 1946 saw the first scheduled KLM flight between Amsterdam and Glasgow, and to commemorate the sixty-fifth anniversary, a 1944 Douglas DC-3 in vintage KLM livery made the same 445-mile journey on Wednesday 17 April 2011. PH-PBA was greeted by a water-cannon salute from the Airfield Fire Service after a flight lasting three hours, twice as long as the 2014 scheduled service. Several passengers entered into the spirit and wore 1940s-style clothes.

Emirates A-380 – Thursday 10 April 2014

On Saturday 10 April 2004, Emirates Airlines commenced a twice-daily service to its hub in Dubai, and in the following decade has carried almost 2.5 million passengers. To commemorate the anniversary, Emirates arranged a special flight by an Airbus A-380, the world's largest passenger aircraft, on Thursday 10 April 2014.

The $380-million aircraft, A6-EET, was just two weeks old. Standing 79 feet from the ground to the tip of her tail fin, and with a wingspan of 261 feet, the 238-foot-long aircraft tips the scales at 617 tons. She was flown by Captain Ian Weir, originally from nearby Clydebank, who was the co-pilot on the first Emirates Glasgow–Dubai flight in 2004. He began his flying career at the airport, washing aircraft in exchange for flying lessons with the West of Scotland Flying Club, and later became a pilot with Loganair.

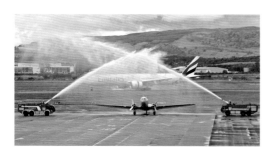

Douglas DC-3C PH-PBA receives a traditional water cannon salute from the Airport Fire Service on the occasion of the sixty-fifth anniversary of the first KLM flight to Glasgow on Tuesday 21 May 1946. An Emirates Boeing 777 taxis past in the background. (Neil Russell Collection)

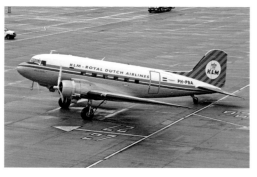

Douglas DC-3C PH-PBA was delivered to the US Eighth Air Force in January 1944 as 42-100971, and participated in Operation Market Garden, the ill-fated airborne assault on Arnhem in September 1944. Purchased by Prince Bernard of the Netherlands in 1946 and registered as PH-PBA (Prince Bernard Alpha), she was used as the official government aircraft until 1961, when she was placed in the Dutch National Aviation Museum. She was restored to airworthy status in 1998. (Neil Russell Collection)

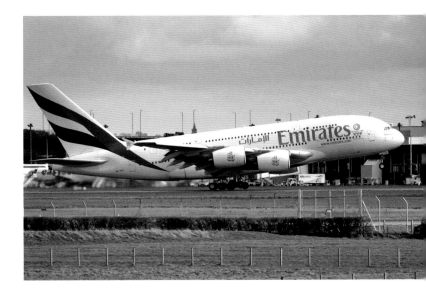

A6-EET on touchdown. (Bill Crookston Collection)

Emirates was an official partner of the XX Commonwealth Games in Glasgow in 2014. (Author)

The graceful lines of the largest commercial passenger aircraft in the world. (Andy Buchannan Collection, via Glasgow Airport)

Family Resemblance.
(Bill Crookston
Collection)

The Jet2 Boeing 737
is over 500 yards
closer to the camera,
yet is still dwarfed
by the A-380.
(Bill Crookston
Collection)

A6-EET taxiing
for take-off. The
pick-up truck
gives scale to the
size of the Airbus.
(Andy Buchannan
collection via
Glasgow Airport)

A6-EET leaves Runway 23. (Andy Buchannan Collection, via Glasgow Airport)

Off into the blue – A6-EET takes her leave of Glasgow. (Author)

Incidents

This may not be the best chapter for nervous flyers to read, but it should be borne in mind that Glasgow International saw 85,000 traffic movements in 2013 alone, putting the following into perspective.

On 23 December 1993, a United Airlines 767 skidded off Runway 23 in icy conditions. Moving the 150-ton, $180-million aircraft took four hours, during which time the main runway was closed.

A Cessna 404 Titan Ambassador II G-ILGW of Edinburgh Air Charter took off on 3 September 1999 to transfer an Airtours crew to Aberdeen. At 500 feet, the port engine failed, the aircraft lost height, and crashed. Eight of the eleven people on board were killed.

BAe 146-200 N407XV was leased by British Airways to cover their Highlands and Islands route due to the late delivery of its new ATPs. She retained her Presidential Airways livery, with the addition of the British Airways logo, and is seen here minutes after an emergency evacuation just after pushback on 26 March 1989, three days after she was delivered. (Neil Russell Collection)

Reims-Cessna FR172F Reims Rocket G-DRAM, damaged by in a gale on 2 January 2007. (Wallace Shackleton Collection)

A Loganair DHC-6 Twin Otter 310, G-BZFP, arrived from Campbeltown with a bump on 22 March 2007, when the nose wheel came off as she taxied after landing. None of the nine people on board was injured. G-BZFP frequently flew the Glasgow–Barra route, which involves a beach landing and take-off (see Loganair chapter), and saltwater had corroded several of the nose-leg components!

On 23 July 2011, a Thomson 757 came within 1,000 feet of colliding with a glider at 3,000 feet 11 miles north-east of Glasgow.

On 17 June 2011 smoke was seen coming from an engine of a Loganair Glasgow–Stornoway flight as it taxied to the runway. It was halted and checked by the Airport Fire Service, and the passengers transferred to a replacement aircraft.

Finally, on 2 December 2012 an Airbus A320 came within seconds of colliding with a UFO at 4,000 feet over Glasgow. The 'blue and yellow' UFO passed 200 feet below the airliner, which had 180 passengers and crew on board, but did not appear on air traffic control radar or the aircraft's own TCAS (traffic collision avoidance system). The UK Airprox (Air Hazard Proximity) Board ruled out an aircraft, helicopter, hot-air balloon or hang-glider but 'was unable to trace any activity matching that described by the A320 pilot ... and had insufficient information to determine the cause'.

De Havilland Canada DHC-6-310 Twin Otter G-BZFP. On 22 March 2007 her nose wheel collapsed just after landing at Abbotsinch due to corrosion by salt water– she regularly flew the Barra route, which involved landing on a beach. (Nigel Garrigan Collection)

Terrorism

At 1511 hours on Saturday 30 June 2007, the second-busiest day of that year, Glasgow airport was the target of a terrorist attack. A blazing Jeep Cherokee 4x4 vehicle, loaded with gas cylinders, attempted to crash through the main terminal doors and into the crowded check-in area. Although flames from the vehicle enveloped the front of the building, no one was injured. The two men in the Jeep were apprehended by members of the public, airport staff and police, and the fire was extinguished by Strathclyde Fire and Rescue and the airport's own firefighting unit.

The airport crisis team was operational within forty-five minutes, quickly putting well-rehearsed plans in motion. All inbound flights were diverted to Edinburgh, Prestwick and Newcastle, and all outbound flights were held on the ground, with around 4,500 passengers being evacuated to the Scottish Exhibition & Conference Centre (SECC) in Glasgow.

A temporary check-in area was set up in T2, and although several flights were cancelled, at 0737 on Sunday 1 July, a mere sixteen hours and twenty-six minutes after the initial incident, the first flight arrived from Ibiza. The first departure was at 0900, and the main terminal was reopened just twenty-three hours and fifty-nine minutes after the fire.

The attack led to wide-ranging changes to vehicle access at airports throughout the world. At Glasgow itself, temporary access arrangements were in place within twenty-four hours, and a £4-million upgrade programme completed in June 2010 resulted in 300 steel bollards and bombproof glass being installed along the front of the terminal. A reorganisation of the airport roads improved passenger pick-up and drop-off facilities, gave a higher priority to public transport and enhanced passenger security – all, like every other improvement made at the airport over the years, at no cost to the taxpayer.

The Flightpath Fund

The Glasgow Airport Flight Path Fund, established in 2010, is designed to ensure communities surrounding the airport in Renfrewshire, East and West Dunbartonshire and Glasgow share in its success, and focusses on community investment, such as charitable organisations and innovative projects in three areas: education, employment and the environment. Since its formation, it has awarded in excess of £700,000 to more than 200 community groups and charities, and in 2013 alone the Fund made awards totalling more than £200,000.

The Tree Amigos, a unique project which encourages youngsters to respect and care for the environment, received £11,000 from the Flightpath Fund. (Glasgow Airport)

Based at the former Rolls-Royce plant in nearby Hillington, the charity will give go-karting sessions to people with additional support needs and learning difficulties, and four of its specially adapted electric carts were paid for by a donation of almost £40,000 from the Flightpath Fund. (Glasgow Airport)

The White Lady

Every wartime aerodrome has its ghosts, but Abbotsinch differs from the usual in that the ghost is not an airman. Legend has it that during the war an aircraft left for an exercise off the west coast of Scotland, but failed to return. The pilot's wife refused to believe he was not coming back, and waited in vain for his return until she too eventually passed away. Her spirit is said to return every night to continue her fruitless vigil. Known as 'The White Lady', she has been seen many times near Gate 5 in the east pier.